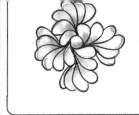
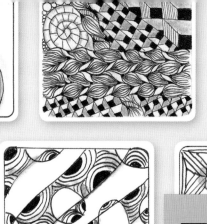
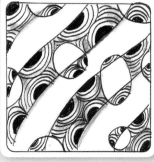

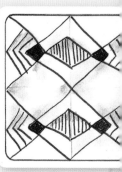

Zentangle
SOURCEBOOK
THE ULTIMATE RESOURCE FOR MINDFUL DRAWING

JANE MARBAIX

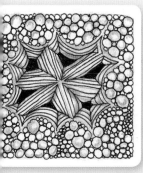
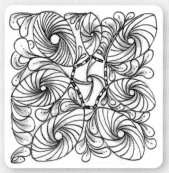
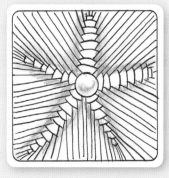
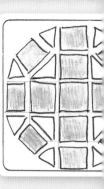

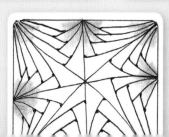

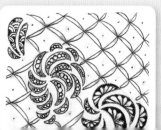

ARCTURUS

ARCTURUS

This edition published in 2022 by Arcturus Publishing Limited
26/27 Bickels Yard, 151–153 Bermondsey Street,
London SE1 3HA

ISBN: 978-1-78428-248-6
AD004918UK

Printed in China

Zentangle
SOURCEBOOK

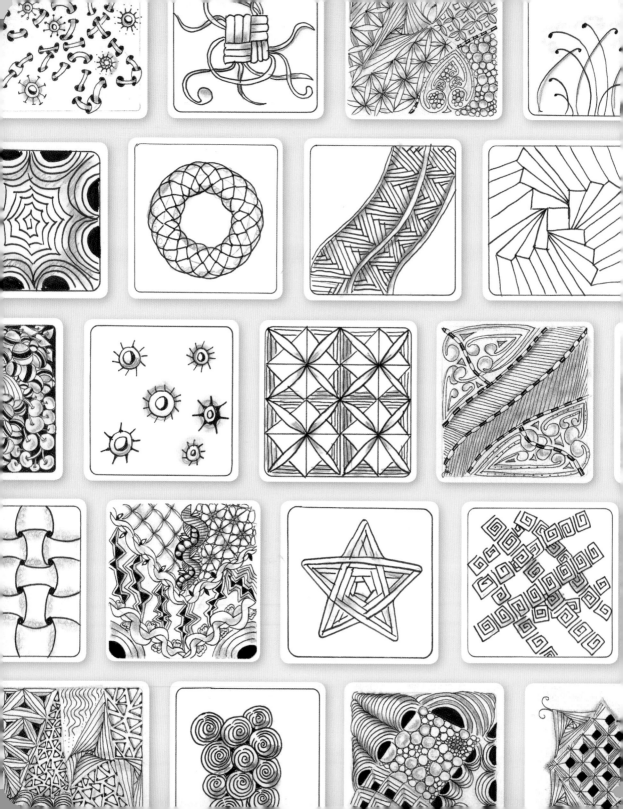

INTRODUCTION

The Zentangle Method was created in the USA by Rick Roberts and artist Maria Thomas. Now hugely popular internationally, it is easy to learn, fun to do and very relaxing. This way of drawing uses many different patterns (tangles), with 'strings' creating spaces to contain them. It is very inexpensive as it requires only a couple of pens, a pencil and some paper, and a tortillon (paper stump) for blending.

This book is a reference guide for tangles, including many favourites as well as some more unusual ones. Most of the tangles and strings are taken from tanglepatterns.com, where you can find a large number to choose from. It is not difficult to create your own strings, but if you need some help this is an easy alternative. For each tangle I have chosen a string that you can use, but you might like to find or draw your own. The amazing tanglepatterns.com site was created by Linda Farmer CZT, who, after Rick and Maria, has been the most influential figure in the Zentangle world. If you are short of inspiration any time, just go to the website and pick any of the designs that you like – and when you feel really inspired, send in your own tangles and strings and if Linda finds them interesting they will join the multitudes already there!

Here I have used the official Zentangle tiles, which can be obtained from www.zentangle.com in the USA or woodware.co.uk in the UK. You can make your own from good-quality watercolour paper or card stock if you wish. The very best paper, for example Fabriano Tiepolo, which is used for the official tiles, will probably give you the best results, but you can really tangle on anything, including fabric.

The pens used in the book are Sakura Pigma Micron 01 and 08 in black and sepia. You will also need a 2B pencil for shading, or a pencil in another soft grade if you prefer.

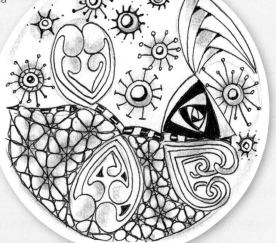

The Importance of Strings

The whole basis of the Zentangle Method rests on the string that you create to begin the process. This divides your tile, or larger piece of paper, into separate spaces in which to draw your tangles. This book mainly focuses on Linda Farmer's website www.tanglepatterns.com, where you can access at least 200 different strings. If you subscribe to the site you will receive an email with a new tangle or string, or a refresher on some of the established tangles, almost every day of the year. You can also buy Linda's ebooks with all the strings illustrated, which is a good way to support all the work that Linda does with her free website. There is an ebook of all the numerous tangles on the website, too, with a small picture of each one.

003

Strings are always drawn in pencil so that they disappear into the finished Zentangle artwork. They can be any shape you wish – curves or straight lines or a mixture of both. You can use each string over and over again with different tangles or, for another approach, create a Monotangle, doing variations of the same tangle in each space.

004

Depending on the look you want, you may choose to give the tile a border before you draw your string. A string is only a guideline, so feel free to take your pattern over a line or add an extra one. There is no right or wrong way up, which adds to the versatility of Zentangle. If you were to do the same string on six tiles then fill them all in with a different tangle in each space and put them all together – upside down, sideways, right way up – it would be hard to tell that you had used the same string each time.

005

Shown here are six of the official strings from tanglepatterns.com. Some strings are suited to particular tangles – for example, Zander and Tipple go well in strings 012 and 007 respectively and grid patterns such as 'Nzeppel would lend themselves to 005 as it is quite an angular set of shapes. However, there are no hard and fast rules about this and you can exercise your own judgement about what looks good to you.

007

You will find a variety of different strings to use in this book, but do try drawing a random string of your own creation sometimes – experimenting can give you exciting results as well as a lot of personal satisfaction.

012

011

Getting Started

Take a Zentangle tile, which measures 9cm (3½in) square. You can use the official ones or cut out your own using a good-quality paper such as a smooth watercolour paper, or Fabriano Tiepolo printmaking paper if you would like to use the same material as the official tiles. However, you could do all your Zentangle artwork in a sketchbook if you prefer.

Still using your pencil, lightly draw some lines within the frame. The string is just a guideline – you can go over the lines or add other lines if you wish.

Start by drawing a dot in each corner with your pencil and joining them up to form a frame.

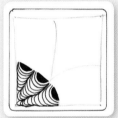

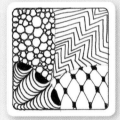

Next, pick up your 01 pen and draw the tangle Crescent Moon in one of the spaces.

Pick another tangle, in this instance Tipple, for one of the other spaces.

Now fill the third space with Static.

Finally, fill the last space with Florz.

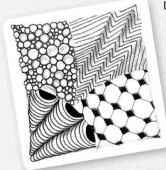

Draw all these strokes deliberately and slowly, focusing on the stroke you are doing. To finish, shade your tile and see the little piece of artwork that you have created.

You can now go through the book and explore the tangles you like. Use one of the many strings you will find or, if you prefer, create your own strings by letting your pencil wander around the tile.

When a Zentangle tile is finished, the custom is to put your initials somewhere on the tile, add the date on the back and write any thoughts you have or just where you happen to be. Now hold the tile at arm's length and admire it from all directions!

AMBLER

A Zentangle® original

This is an easy step-out to follow, especially
if you start in the middle of the maze-like
shape rather than going from outside in.
You could do this tangle on a larger ZIA
(Zentangle Inspired Art), letting it amble
through your artwork.

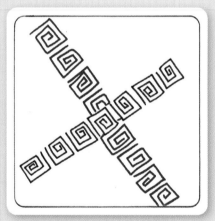

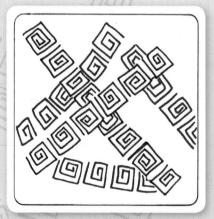

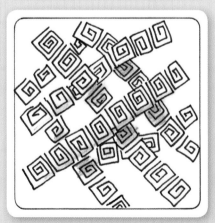

STRING 111

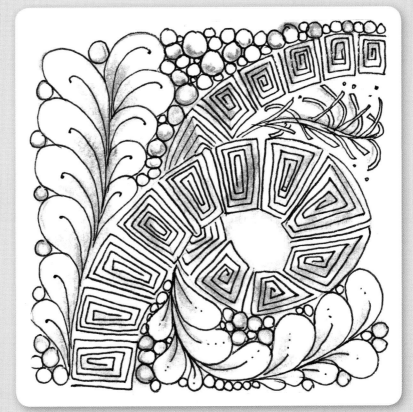

Tangles used:
Ambler, Flux
and Tipple.

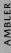

AMELIACHELE

Amy Broady CZT, USA
tanglefish.blogspot.co.uk

Ameliachele is a tangle
with a pretty shell-like
appearance. I chose this
string with a circle in the
middle as it lent itself to
drawing two Ameliacheles
facing each other with
some Tipple in the middle.

STRING 127

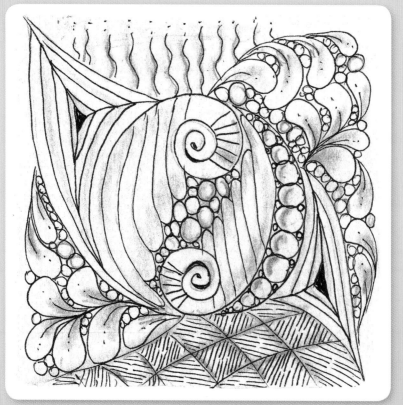

Tangles used:
Ameliachele,
Flux, Msst,
Paradox, Tipple,
Yincut.

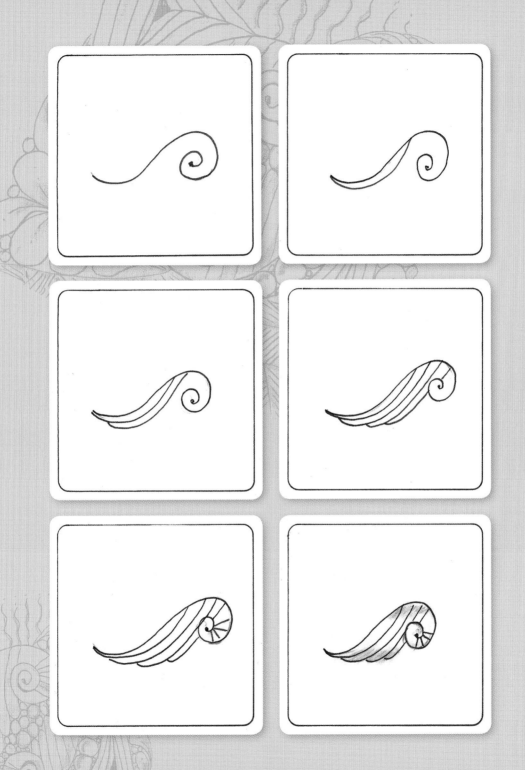

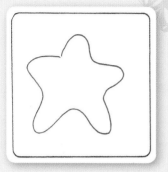

AQUAFLEUR
A Zentangle® original

Some highlights can be added to this tangle for effect. It is ideal for a floral or seascape picture. The shape is fairly simple, made more dramatic by shading and highlighting.

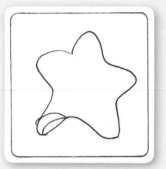

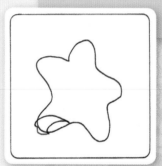

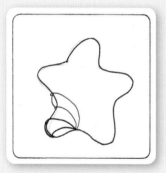

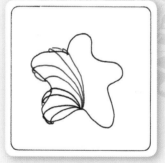

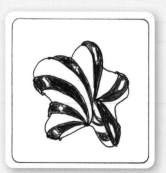

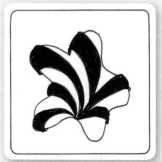

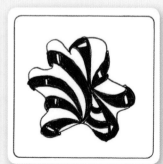

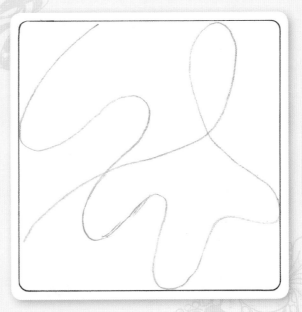

STRING 030

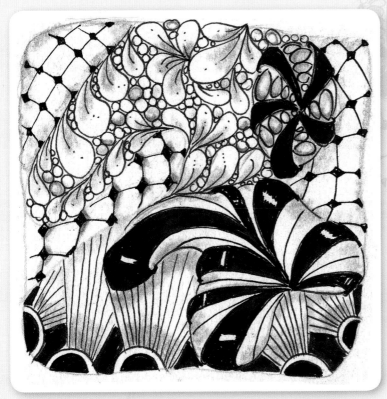

Tangles used:
Aquafleur, Florz,
Flux, Footlites
and Tipple.

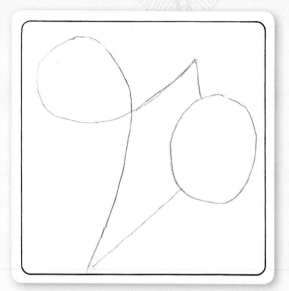

STRING 061

ARUKAS

A Zentangle® original

This can be varied by altering the number of 'spokes' used. Take care to follow the step-out accurately, adding the circles between each round of 'spokes'.

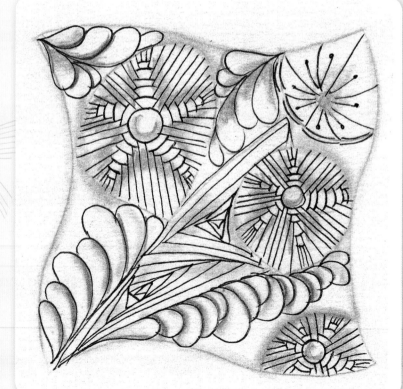

Tangles used:
Arukas, Flux,
Marbaix and
Paradox.

AURAKNOT

A Zentangle® original

You can choose the number of star spokes you put in this tangle. It doesn't need to be an even star-shape and it's fun to see how it evolves.

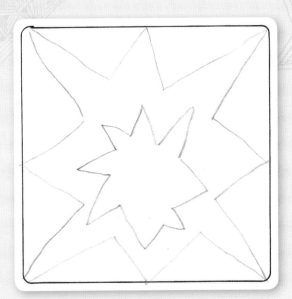

STRING 082

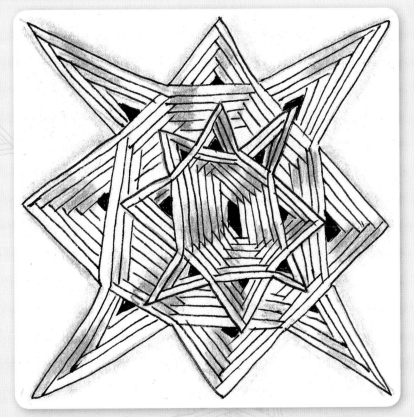

Tangle used:
Auraknot only.

BASK-IT

Anna Houston CZT, Canada

I love this tangle, though some care is needed to get the wavy lines lining up. It is very effective when shaded.

STRING My own

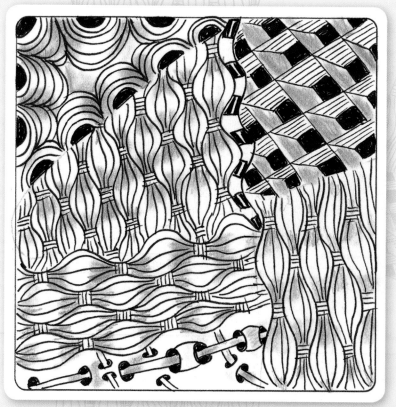

Tangles used: Bask-it, Crescent Moon, Cubine and Laced.

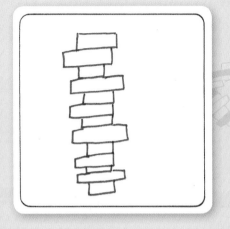

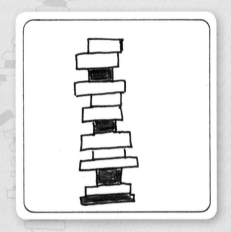

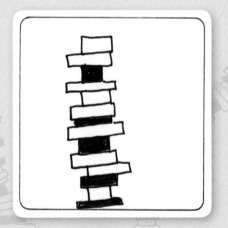

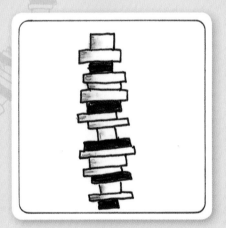

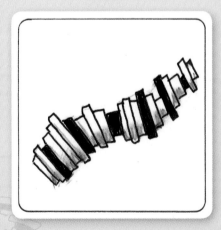

BB

A Zentangle® original

This is a fun tangle to do as it is easy and you can weave it through a larger ZIA (Zentangle Inspired Art). Stack the 'bricks' vertically or horizontally, maybe doing them in a curve.

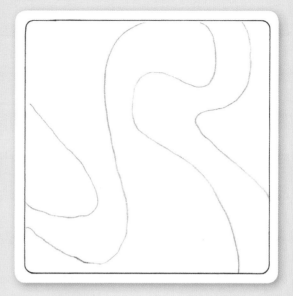

STRING 042

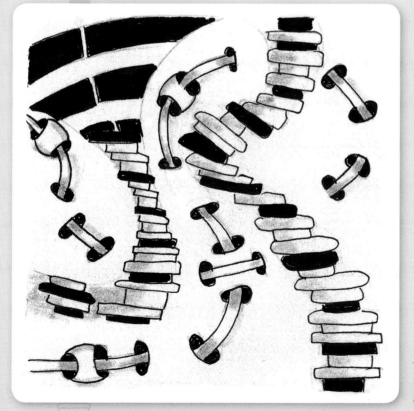

Tangles used:
BB, Btl Joos
and Laced.

BETWEED
A Zentangle® original

This tangle can be done in a circle, a square or a straight line – you could make an attractive border by drawing it horizontally and vertically. Add a little weight to it by doing a tiny triangle where the lines meet.

STRING 090

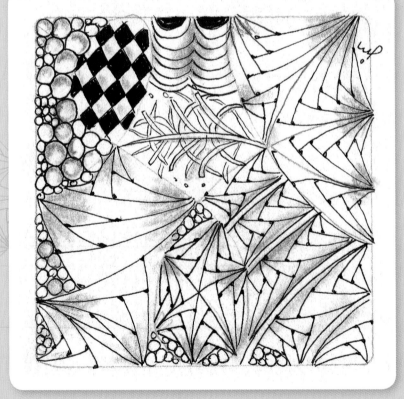

Tangles used: Betweed, Knightsbridge, Tipple and Verdigogh.

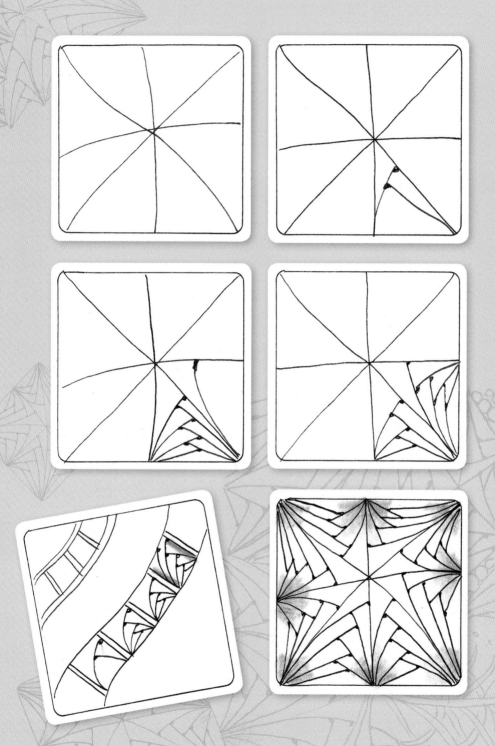

BINDA

Claire Crooke CZT,
Australia

When you're drawing
this tangle, take care to
observe where the curvy
lines go over and under
the circles. There is a lot of
scope to vary it, as you can
see from the finished tile.

STRING 015

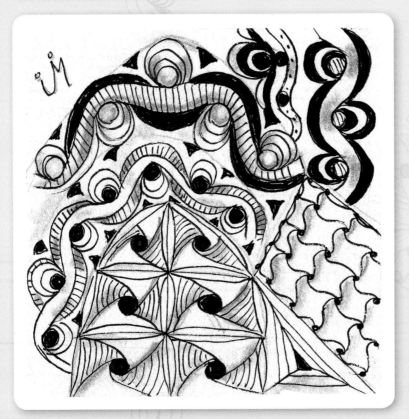

Tangles used:
Binda, Cadent,
Paradox and
Yew-dee.

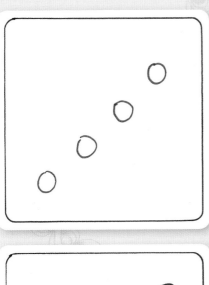
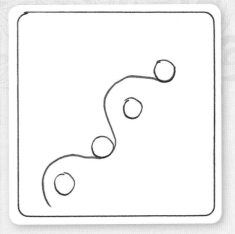
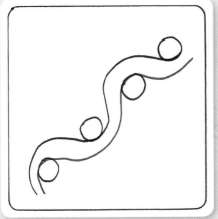
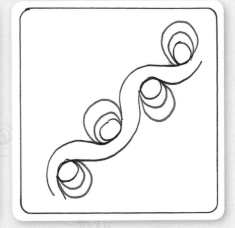
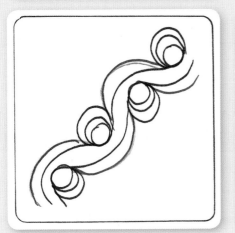
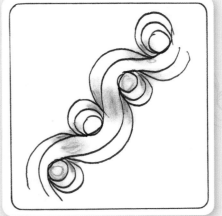

Tangles used:
Bales, Biscus and
Footlites.

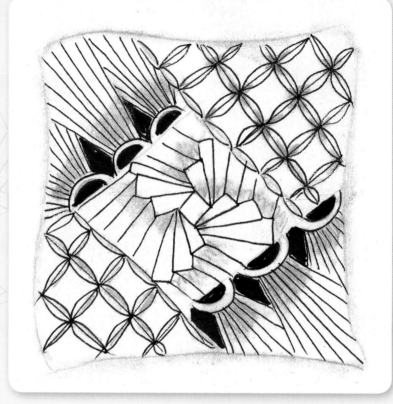

STRING 008

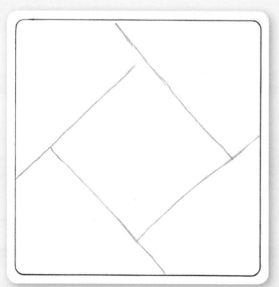

BISCUS

Vicki Bassett CZT, USA

Many tangles are easy
enough to use straight away
in your artwork, but it is
advisable to practise this one
first as you need to draw a lot
of diagonals quite accurately.

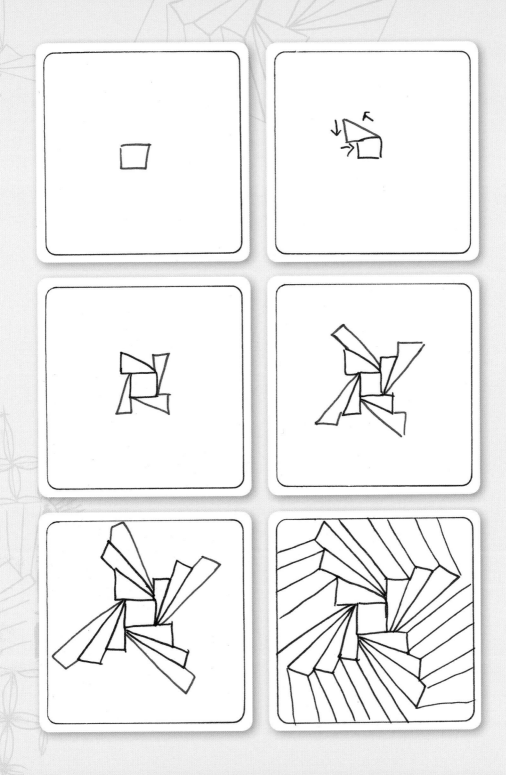

BRAYD

Michele Beauchamp CZT, Australia
www.shellybeauch.blogspot.co.uk

Brayd is a little like Zander (see p.156–7) in the way it can be weaved through a larger ZIA (Zentangle Inspired Art).

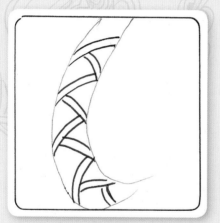

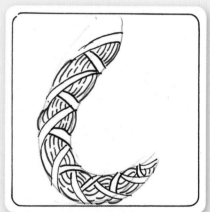

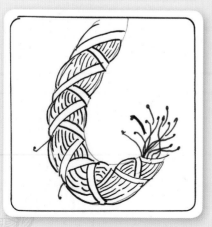

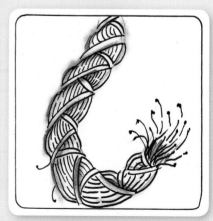

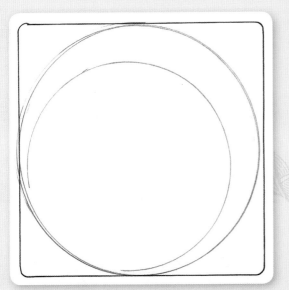

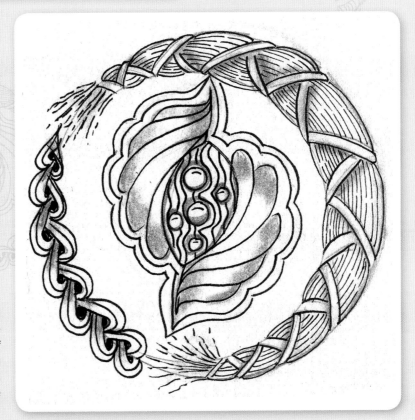

Tangles used:
Nipa in the
centre of
Abundies with
Heartrope and
Brayd on the
outside circle.

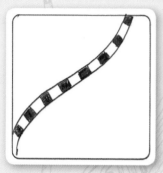

BTL JOOS

Sandy Steen Bartholomew CZT, USA

I use this tangle a lot to run through my artwork. Leave a highlight for the best effect. Btl Joos can be drawn very wide (see p.54–5) or narrow as I have done in this illustration.

There are two ways of doing Btl Joos. You can start with the outer lines and then fill in the 'blocks', or you can draw a faint pencil line in the direction you would like Btl Joos to go then draw the 'blocks' first and join them together with a curved line, as I have done (bottom right).

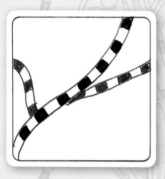

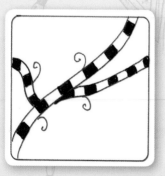

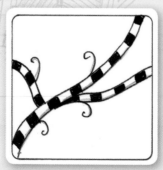

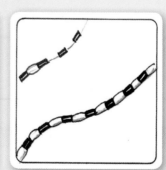

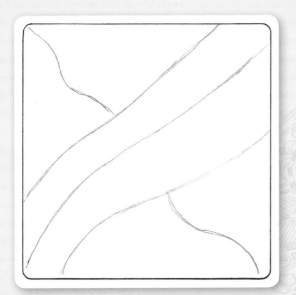

Tangles used:
Btl Joos, Meer
and Mooka.

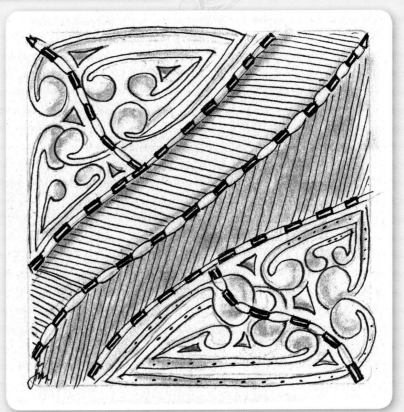

CADENT

A Zentangle® original

A favourite with many people, Cadent is very easy to do once you get the hang of it. When you have joined the circles with an S shape, turn the tile by 90 degrees and join the circles with the same S shape.

STRING 088

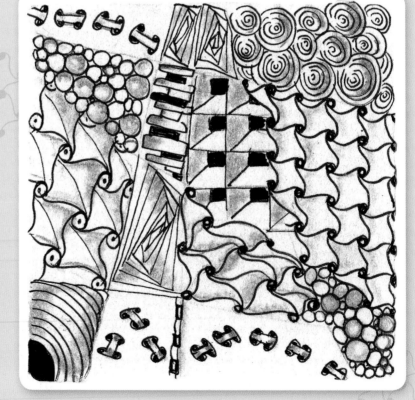

Tangles used: BB, Btl Joos, Cadent, Cadent variation, Cubine, Laced, Paradox, Printemps and Tipple.

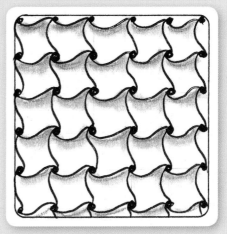

Tangles used:
Chemystery,
Crescent Moon,
Hollibaugh and
Tipple.

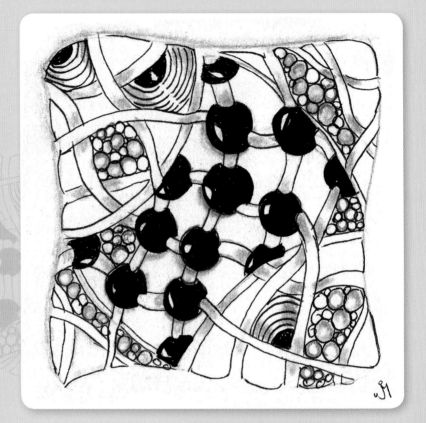

STRING 073

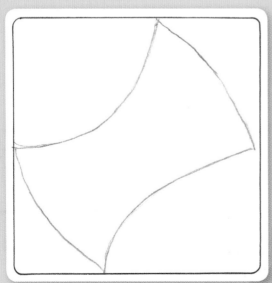

CHEMYSTERY

MaryAnn Schablein-Dawson
CZT, USA

I love this tangle because
it looks so effective when
included along with other
tangles. It's fun to experiment
with it, too.

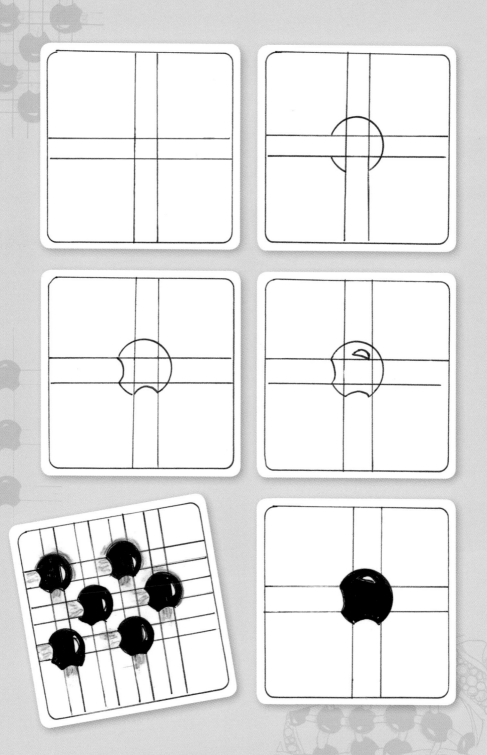

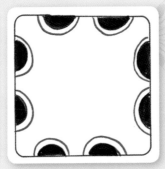

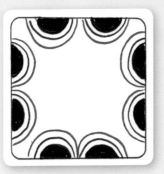
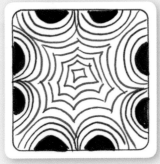

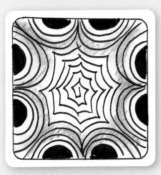

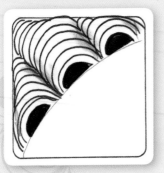

CRESCENT MOON

A Zentangle® original

Crescent Moon is one of the first tangles CZTs teach, along with its many variations. I use an 08 pen to fill in the crescents.

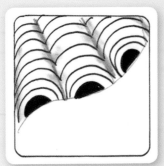
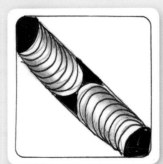

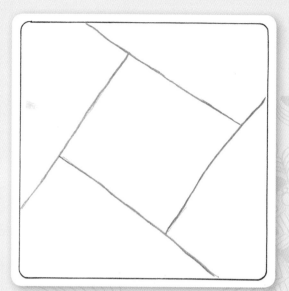

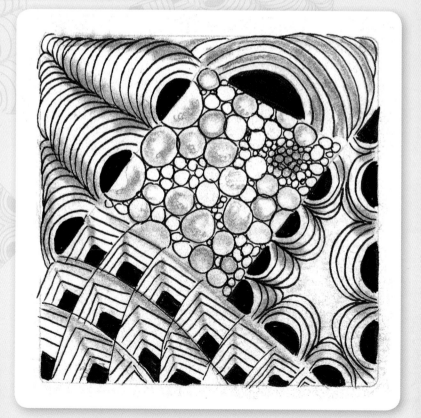

Tangles used:
Crescent Moon
variations, Flukes
and Tipple.

CRESCENT MOON

CRUFFLE

Sandy Hunter CZT, USA
tanglebucket.blogspot.
co.uk

I use this tangle a lot to enhance the greetings cards that I make. It is also very effective combined with Flux.

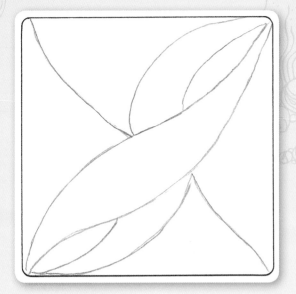

STRING 046

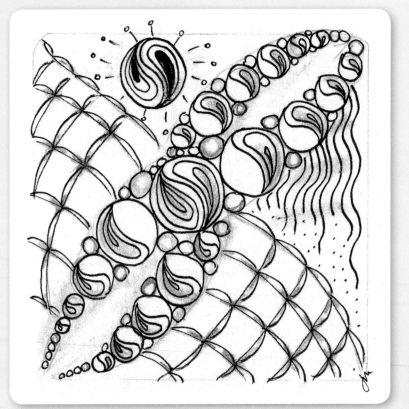

Tangles used:
Cruffle with
Tipple, Chillon
and Msst.

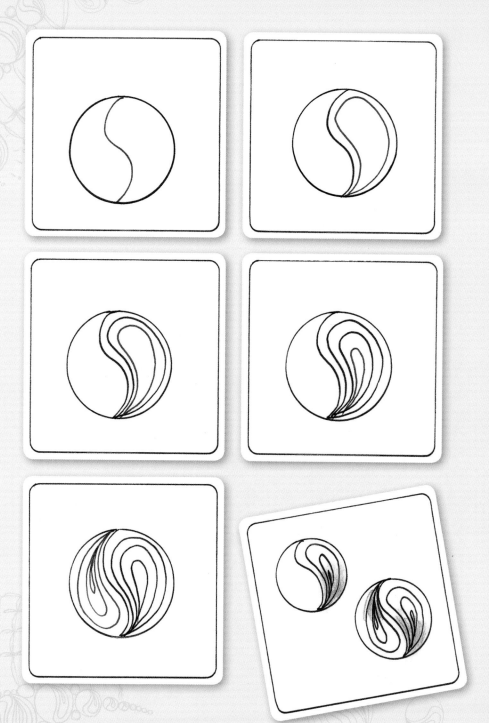

CUBINE

A Zentangle® original

An easy grid pattern which comes into its own when shaded, Cubine can be varied by changing the style of the shading and the size of the grid.

STRING My own

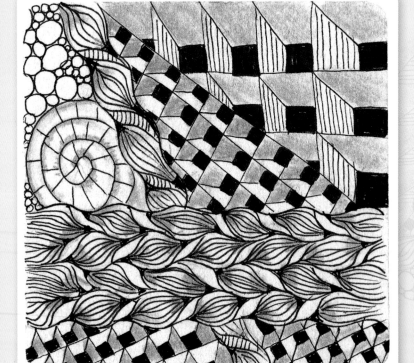

Tangles used:
African Artist,
Cubine, Snail
and Tipple.

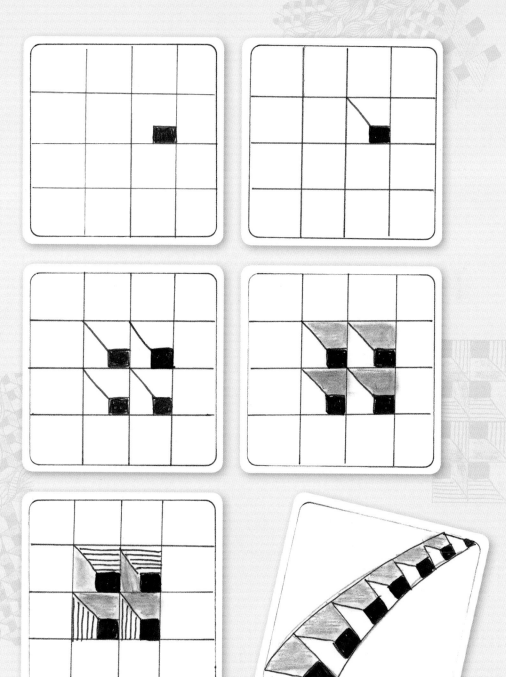

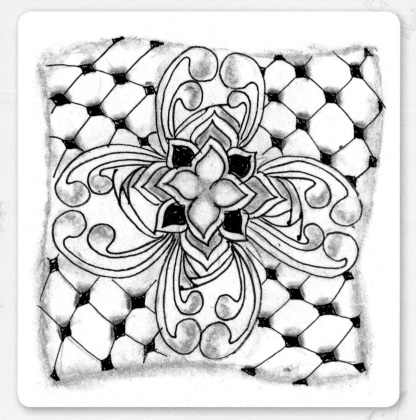

STRING 138

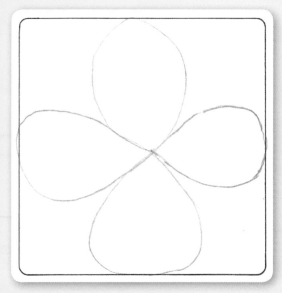

CYME

A Zentangle® original

With its multiple 'layers', this tangle takes a bit of practice but it adds a nice flowery touch. You might like to start with just a few layers as in the tile shown until you feel expert with it.

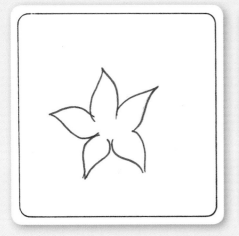

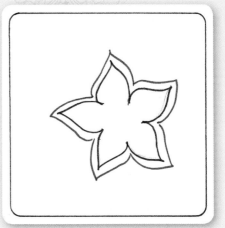

STRING 043

DEX

A Zentangle® original

You'll need to concentrate when you're doing this tangle because it can be a bit confusing, but the end result is effective.

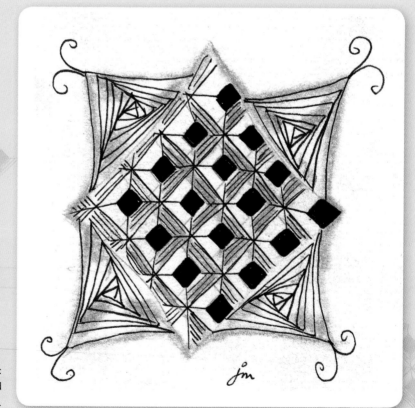

Tangles used:
Dex and
Paradox.

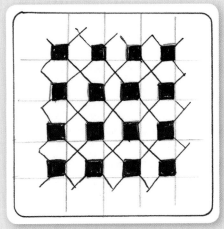
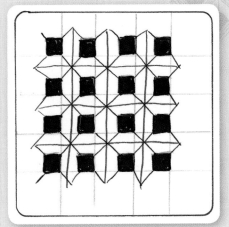
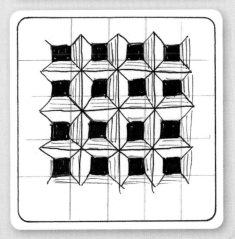
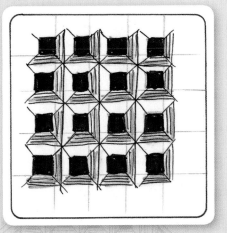

4 CORNERS

Barbara Finwall, USA

This is a very pretty tangle based on a grid. It is easy to vary the shape and the shading.

STRING 084

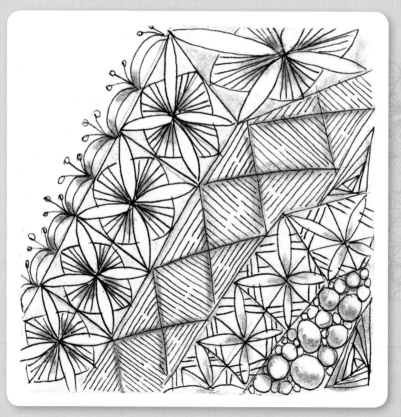

Tangles used: 4 Corners, Paradox, Puf Border, Tipple and Yincut.

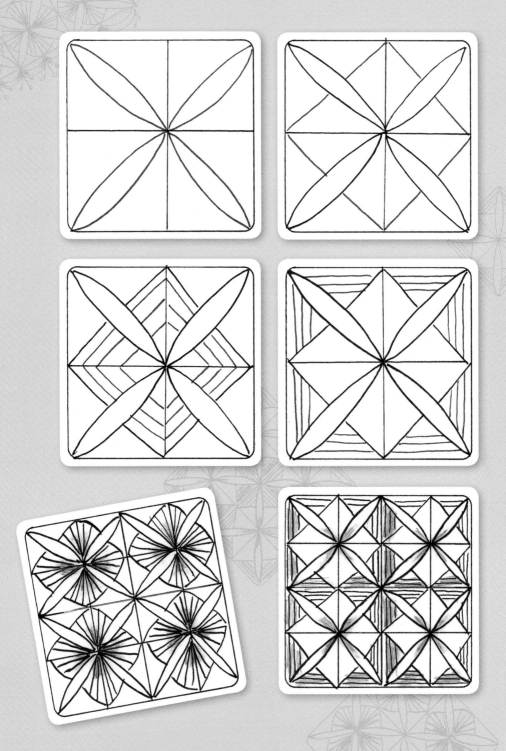

Tangles used: Btl
Joos and Fassett.

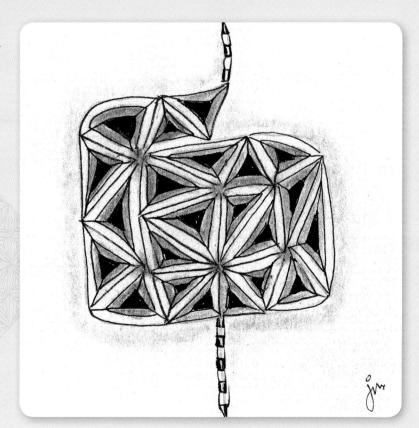

STRING 043

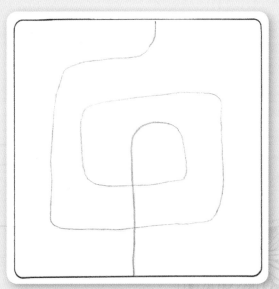

FASSETT

Lynn Mead CZT, USA
www.atanglersmind.com

This is just one of Lynn's
lovely tangles. As you
can see, it is grid-based.
Experiment with shading and
you'll find you can achieve
lovely results.

FESCU

A Zentangle® original

A very simple tangle, Fescu can be made more
dominating by enlarging the size of the 'pod'.
Add it to a flowery tile for a lovely effect.

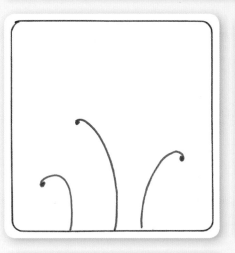

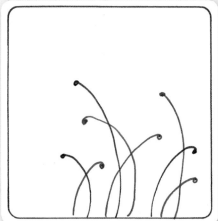

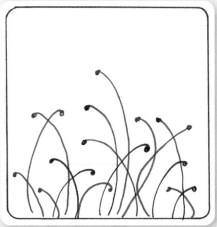

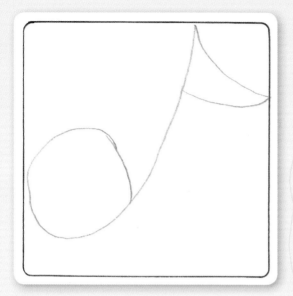

STRING 121

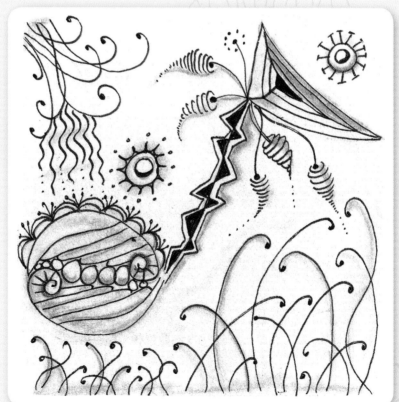

Tangles used:
Ameliachele,
Fassett, Fescu,
Msst, Puf
Border, Widget
and Zinger.

FIFE

A Zentangle® original

There are quite a few
strokes to this tangle, so
don't make it too small
or you may find you don't
have room to complete it.

STRING 123

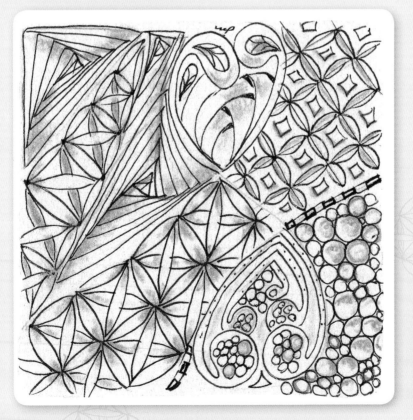

Tangles used:
Bales, Fife,
Paradox and
Mooka with
Betweed and
Tipple.

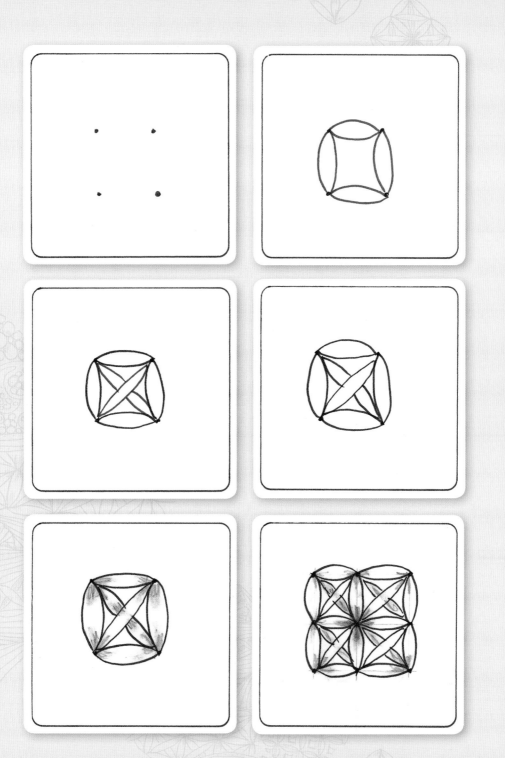

STRING 023

FLORZ

A Zentangle® original

You can vary this tangle by changing the size of the 'diamond' shapes. Each diamond can be shaded individually on two sides for effect.

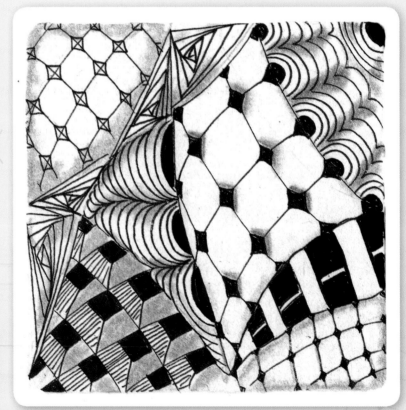

Tangles used: Btl Joos, Crescent Moon, Cubine, Florz variation and Paradox.

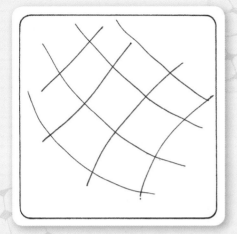

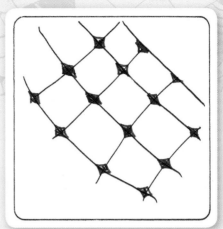

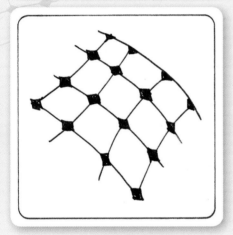

Tangles used: Chillon, Crescent Moon, Flovine, 'Nzeppel and Rain.

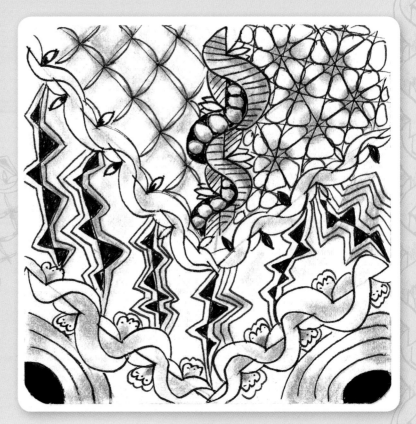

STRING 120

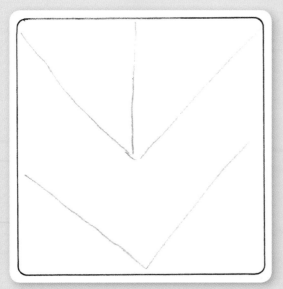

FLOVINE

Lin Chiu CZT

This vine-like tangle offers plenty of scope to vary it, as illustrated in the tile. You can see other variations on tanglepatterns.com.

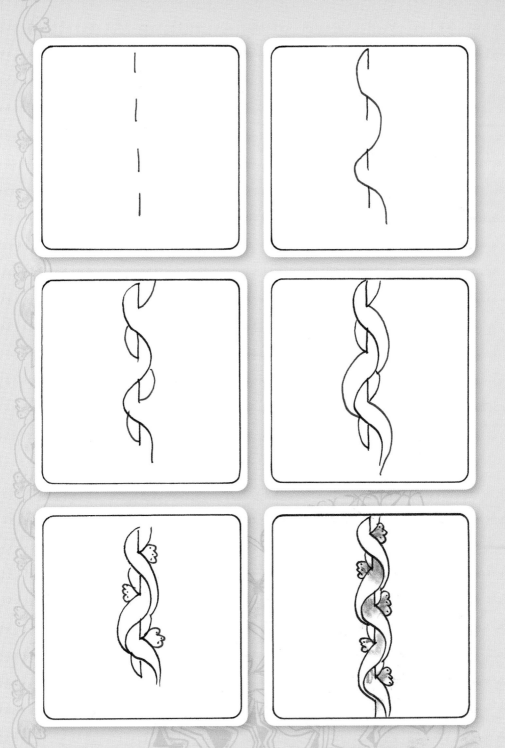

FLUX

A Zentangle® original

I have shown two different ways of drawing Flux – on the left is Maria's version and on the right is Rick's.

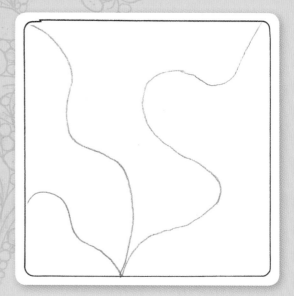

STRING 098

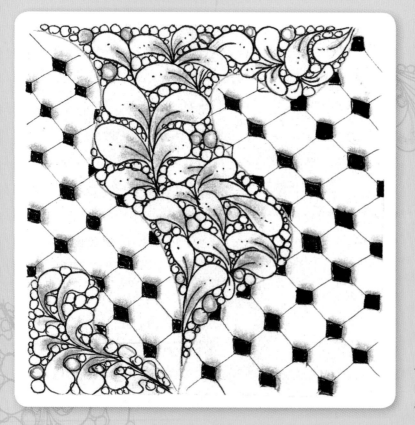

Tangles used: Florz, Flux and Tipple.

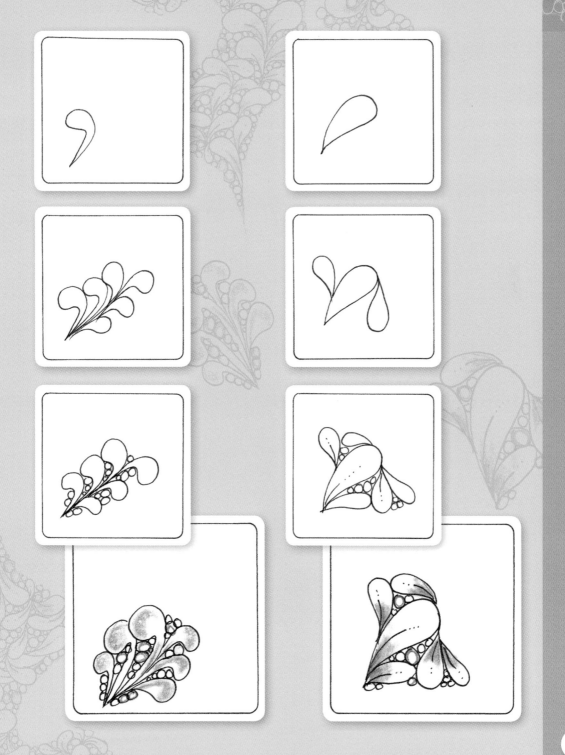

HEARTLINE

Helen Williams CZT,
Australia
alittlelime.blogspot.ca

This is a simple tangle
which I have used here
without a string, just
setting it in a frame to
illustrate it.

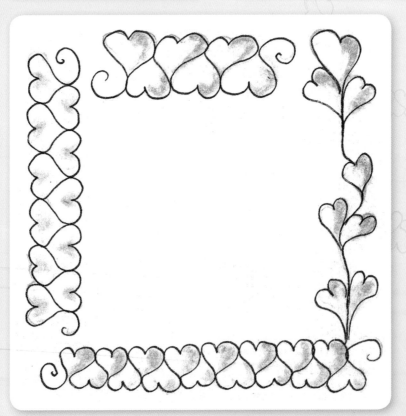

Tangles used:
Heartline only.

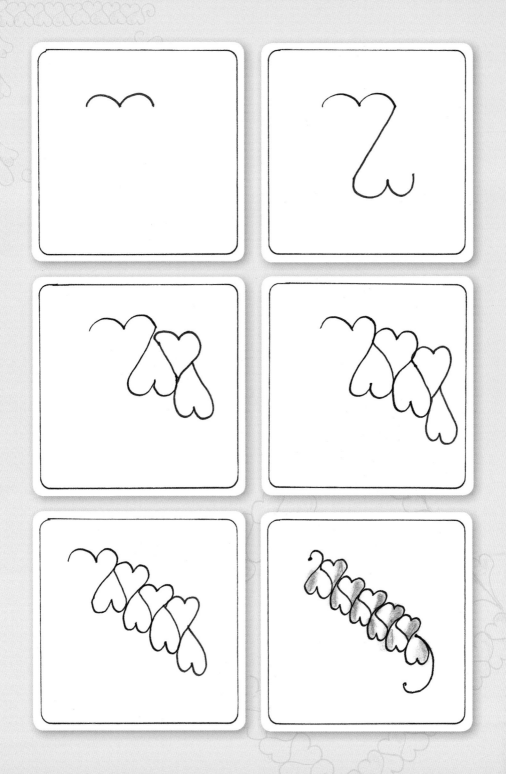

HIBRED

A Zentangle® original

This tangle can be used as a border or as a design running through a ZIA. It is easy if you follow the step-out carefully.

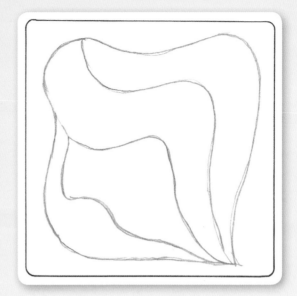

STRING 013

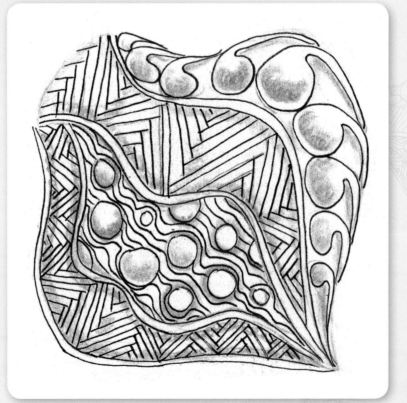

Tangles used:
Hibred, Flux and Nipa.

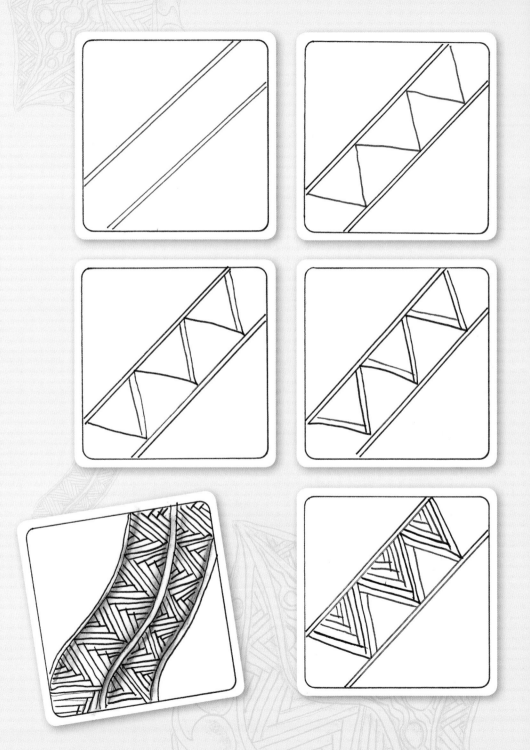

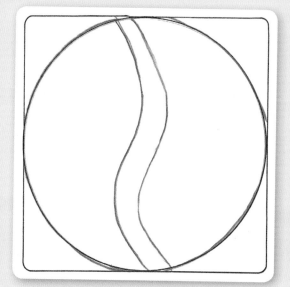

STRING 077

HOLLIBAUGH

A Zentangle® original

Hollibaugh, by Rick and Maria's son-in-law Nick Hollibaugh, is one of the most versatile tangles and shows the 'go behind' method. It can be done with either straight or curvy bands, and filling it in with other tangles is an option too.

Tangles used: Narwal in the middle with Hollibaugh on either side, and Tipple and Crescent Moon in some of the spaces.

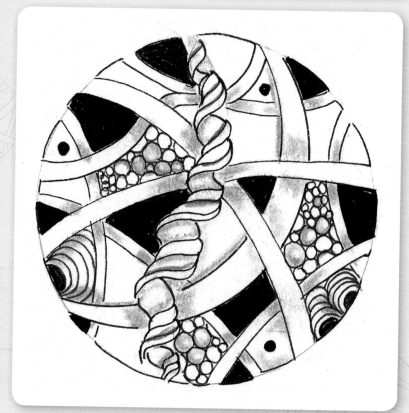

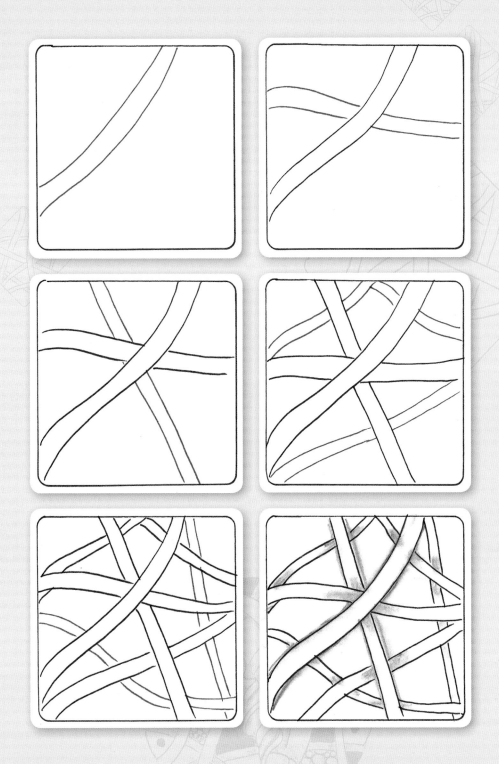

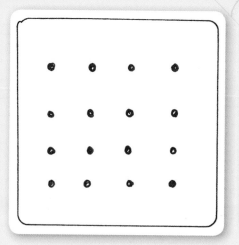

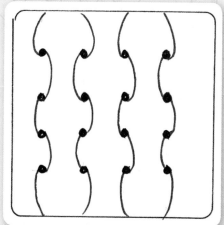

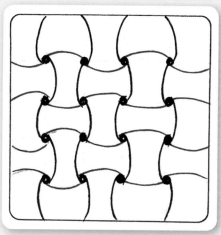

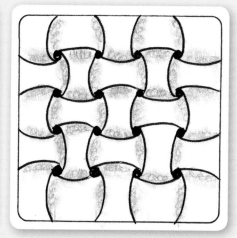

HUGGINS

A Zentangle® original

Huggins is similar to Cadent (see p.32–3) in the way it is constructed, as you start the same way by drawing little circles. However, the stroke you do here is C-shaped rather than S-shaped as with Cadent. After drawing the flattened 'Cs' horizontally, turn the tile to draw the 'Cs' that cross them.

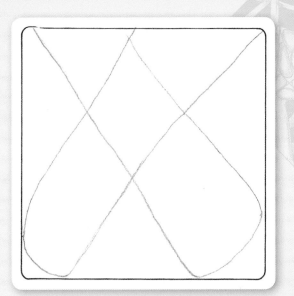

STRING 072

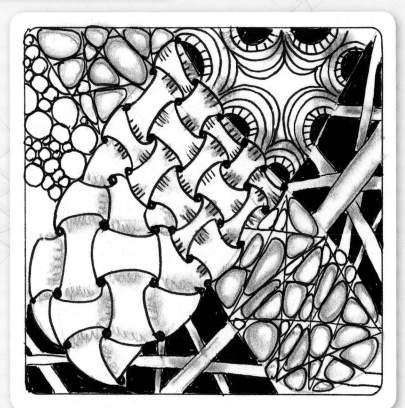

Tangles used:
Crescent Moon,
Hollibaugh,
Huggins,
'Nzeppel and
Tipple.

INDYRELLA

A Zentangle® original

By Rick and Maria's daughter Molly Hollibaugh, this is a very unusual tangle with which you can achieve very different effects, depending on the size that you draw it.

STRING 119

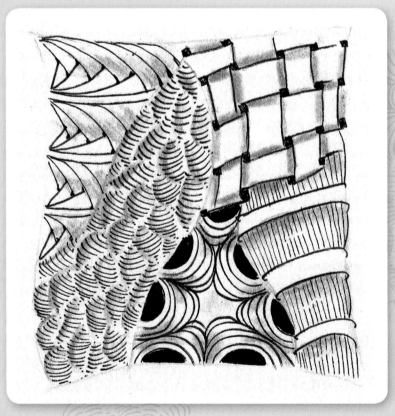

Tangles used:
Betweed,
Crescent Moon,
Indyrella, W2
and Zander.

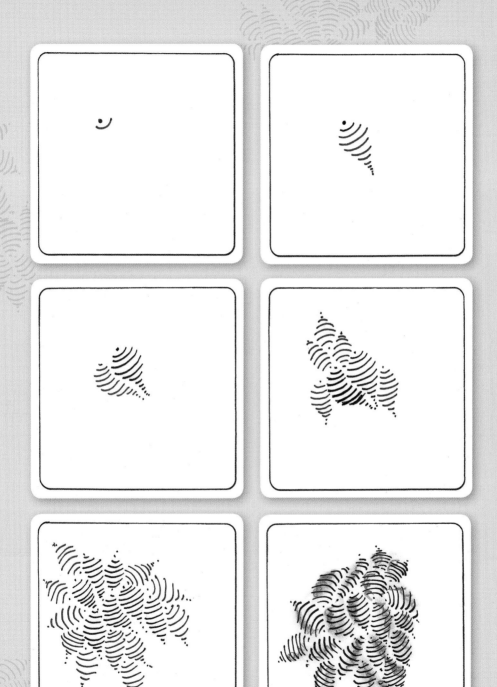

Tangles used:
Betweed, Ing,
Paradox, Rain
and Tipple.

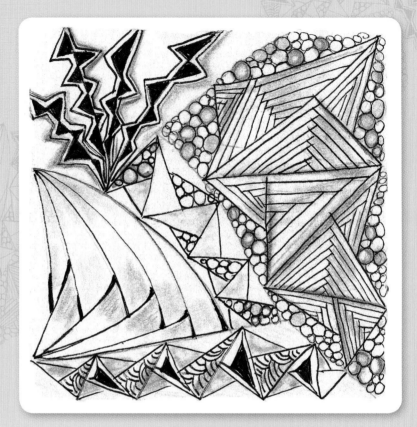

STRING 027

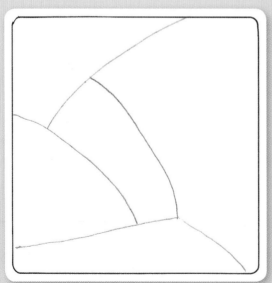

ING

A Zentangle® original

Molly Hollibaugh created this tangle, which was inspired by a modern sculpture. Hard work went into deconstructing the pattern, but it has produced a very easy tangle with lots of scope for variation.

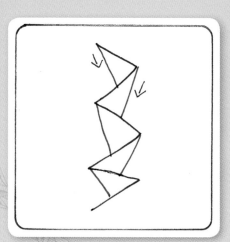

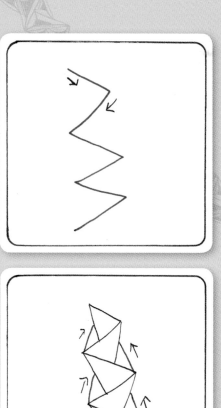

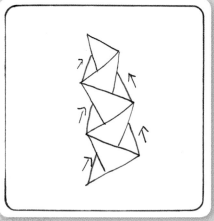

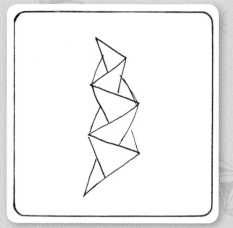

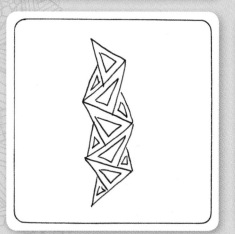

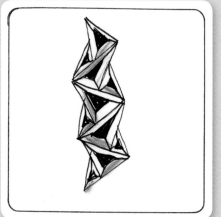

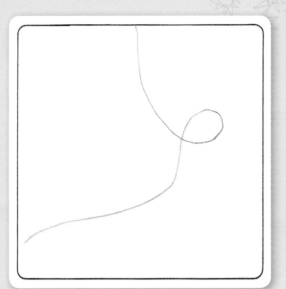

JEST

Amy Broady CZT, USA
tanglefish.blogspot.co.uk

Jest is a fun tangle to run through your Zentangle creations. It can be used as a single Jest or along a 'string', maybe in a circle.

STRING 112

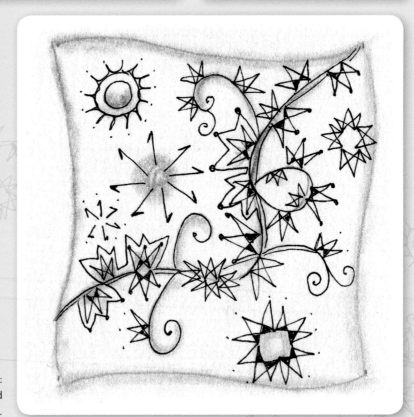

Tangles used:
Jest, Joy and
Widget.

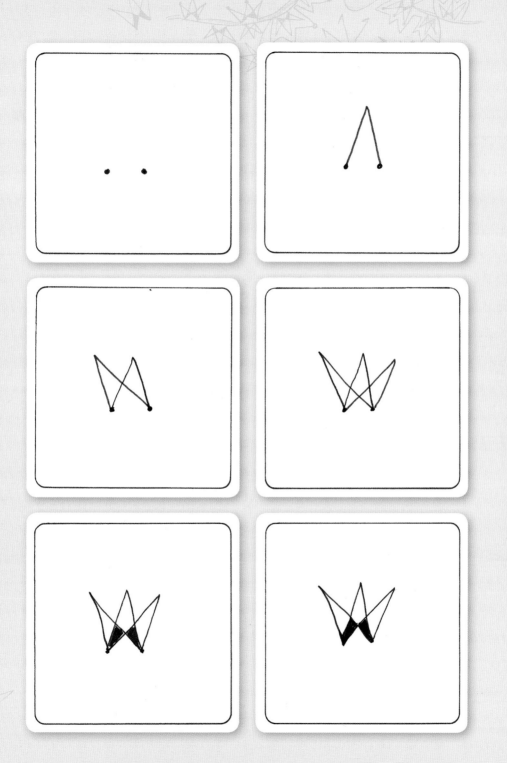

Tangles used:
Jetties, Paradox,
Poke Leaf, Poke
Root, Sparkle,
Static and
Tortuca.

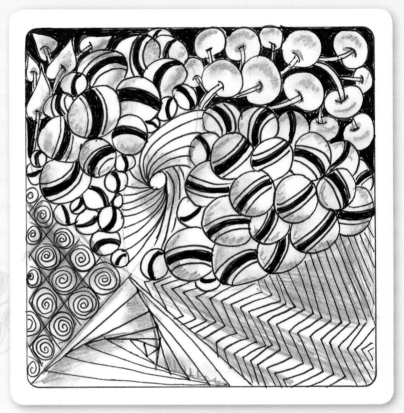

STRING 035

JETTIES

A Zentangle® original

This is like Tipple (see
p.142–3) but has a band
around it that can be
shaded to give a rounded
appearance.

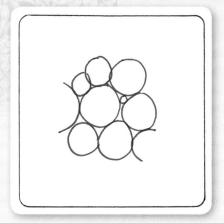

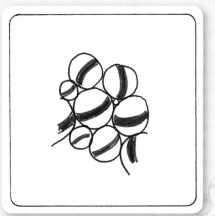

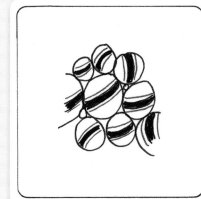

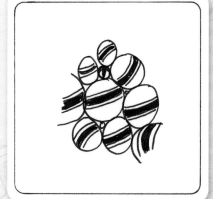

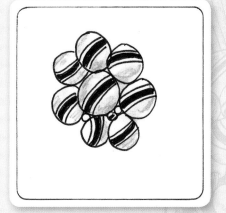

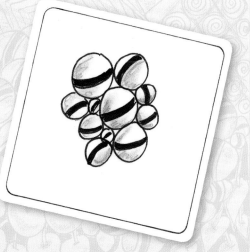

KATHY'S DILEMMA

A Zentangle® original

This tangle might look complex but in reality it isn't too difficult – it's just a matter of getting the triangular shapes quite evenly spaced.

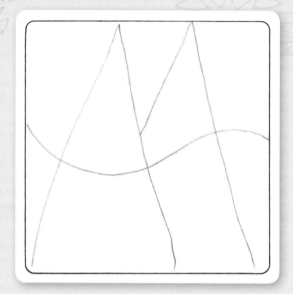

STRING 064

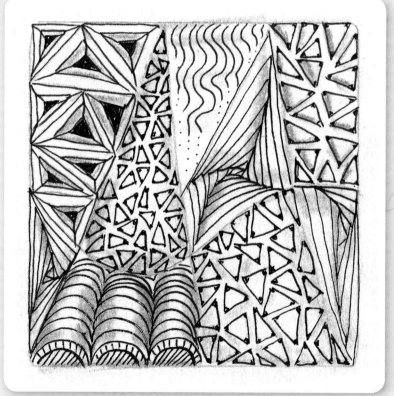

Tangles used: Crescent Moon, Fassett, Kathy's Dilemma, Msst and Paradox.

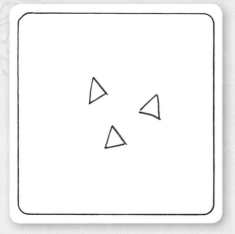

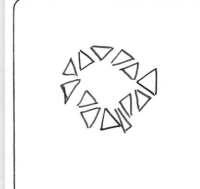

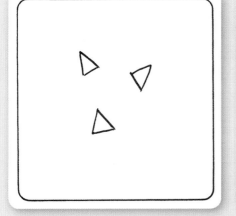

KEEKO

A Zentangle® original

This has a basket-weave appearance. Perhaps surprisingly, it is great for animal fur.

STRING 140

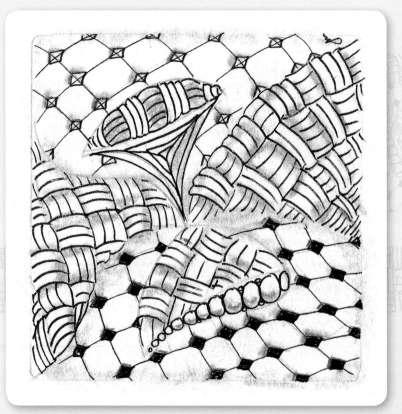

Tangles used:
Florz, Keeko,
Onamato and
Paradox.

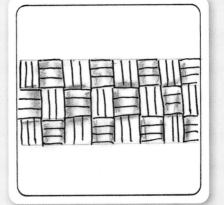

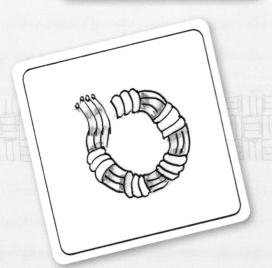

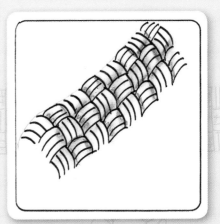

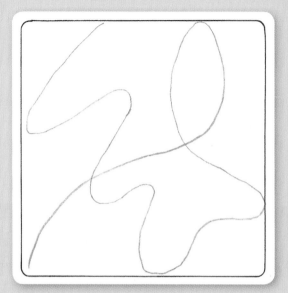

STRING 030

LACED

Mary Elizabeth Martin CZT, USA
pinetreestudiosblog.blogspot.co.uk

Although it is simple, this is an exciting tangle to do, twisting and turning it and adding shading for depth. Its fluidity gives the feeling that a cord is running in and out of the page.

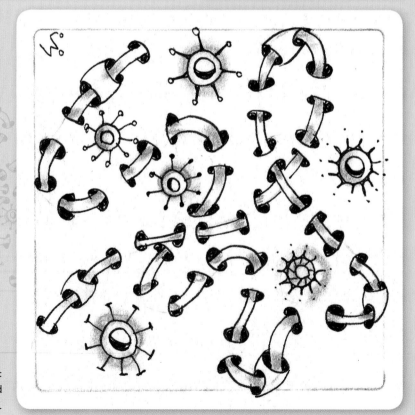

Tangles used:
Laced and
Widget.

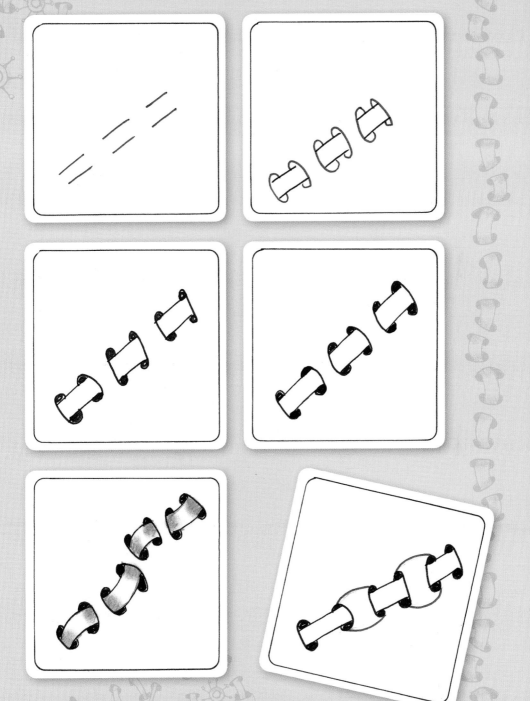

Tangles used:
Frondous,
Hollibaugh,
Leaflet and
Netting.

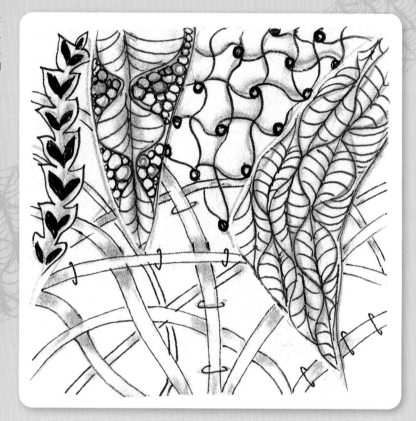

STRING 148

LEAFLET

Helen Williams CZT, Australia
alittlelime.blogspot.ca

Take care drawing the initial
wavy lines in the step-out to
get them evenly matching.
On Helen's blogspot you can
learn more about this lovely
tangle and the different ways
of shading it.

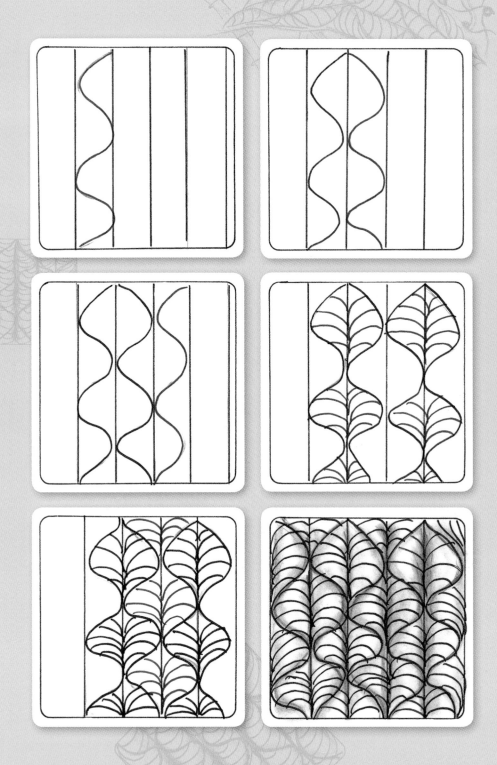

LINQ

Lara Williams CZT, USA
laralina-tangleware.blogspot.co.uk

I created a wavy string to go with this tangle. You can add as many Linqs as you like and by enlarging them you can create enough space to draw other tangles inside the half-moon shapes.

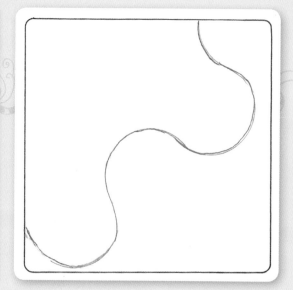

STRING My own

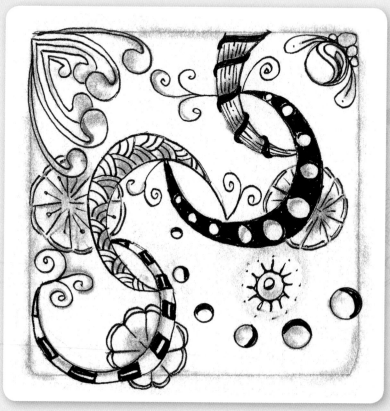

Tangles used: Cruffle, Linq, Marbaix, Mooka, Widget and Zander.

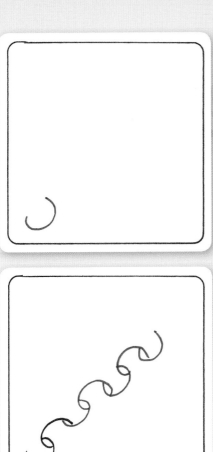

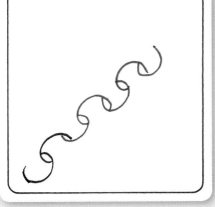
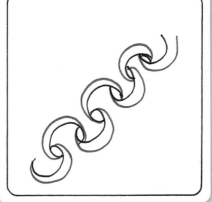
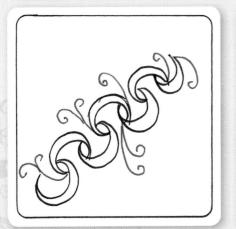
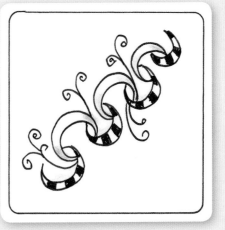

MAK-RAH-MEE

Michele Beauchamp CZT, Australia
shellybeauch.blogspot.co.uk

Macramé is a fascinating craft and this is a wonderful deconstruction of the pattern for you to experiment with. Check out Michelle's blogspot as she is a very talented artist.

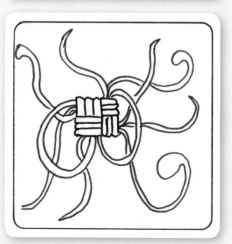

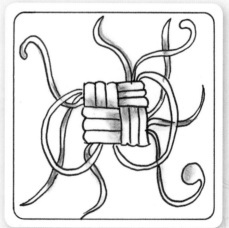

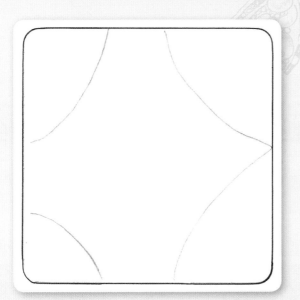

STRING 066

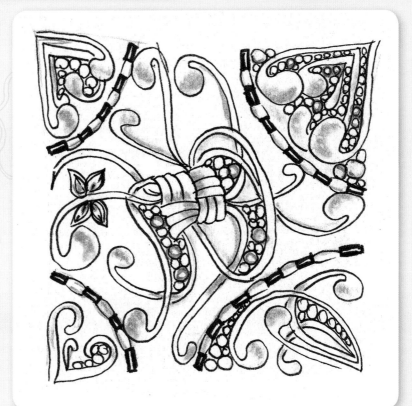

Tangles used:
Btl Joos, Mooka
and Tipple.

MAN-O-MAN

A Zentangle® original

This isn't quite as simple as it looks and you'll probably need a bit of practice to get it right. Different shading gives a range of effects.

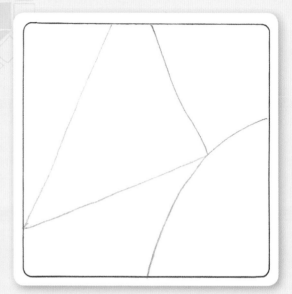

STRING 124

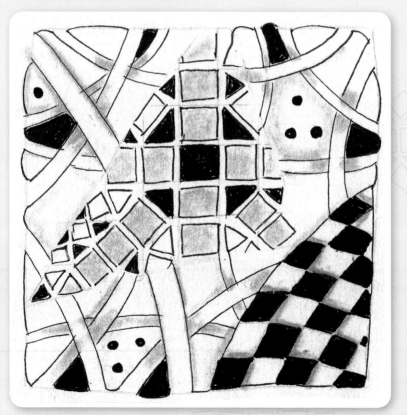

Tangles used:
Hollibaugh,
Knightsbridge
and Man-O-Man.

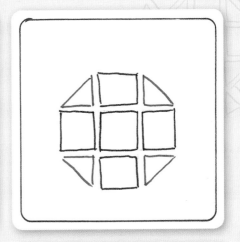

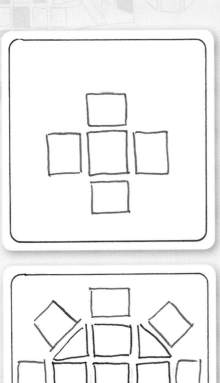

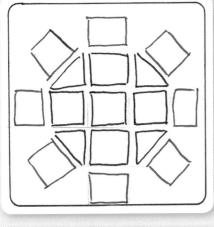

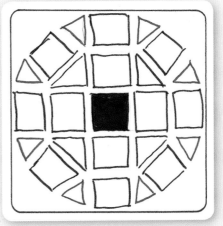

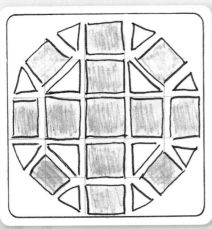

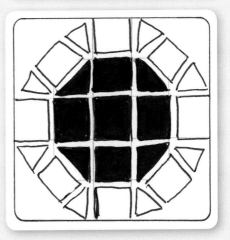

MARBAIX

Jane Marbaix CZT, UK
zentanglewithjane.me janemarbaix@mac.com

Marbaix is very easy to do as long as you follow the step-out rather than drawing random lines in a circle. The variation shown below, which makes it more flower-like, was created by Lynn Mead CZT. The initial circle in pencil can be in the centre or at another point in the larger circle to create a different look, especially after the shading has been done. You do not always need to draw the whole of the circle as you can set it partially behind another tangle or on the edge of a tile as I have done.

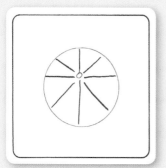

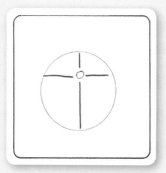

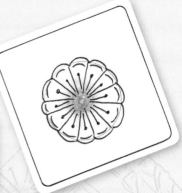

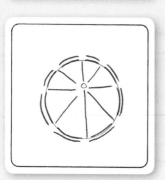

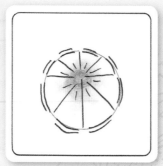

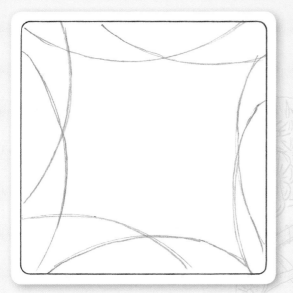

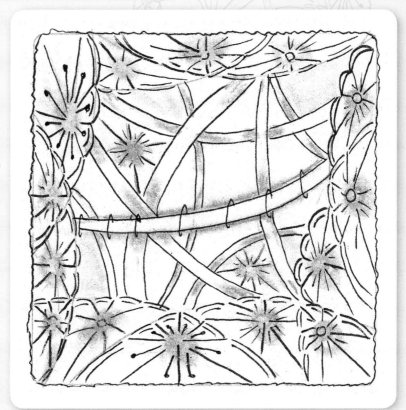

Tangles used:
Hollibaugh and
Marbaix.

MARNIE

Chrissie Frampton CZT, UK

Chrissie's tangle was created from a pattern seen on a decorative folding screen. You can find patterns almost anywhere, but ornamental gates and railings are a particularly good source from which many people derive their ideas. You will find variations on this tangle on tanglepatterns.com.

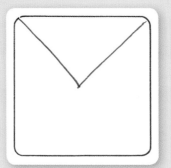
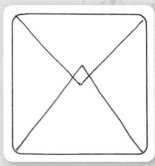

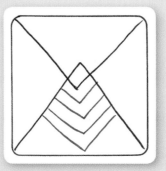
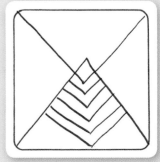

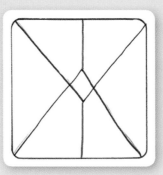
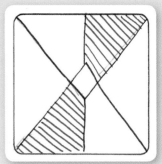

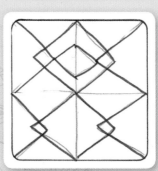
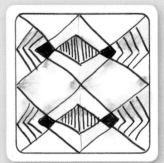

STRING 010

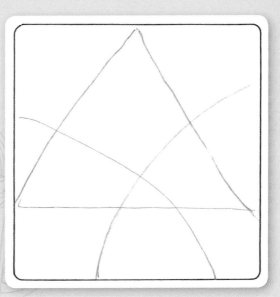

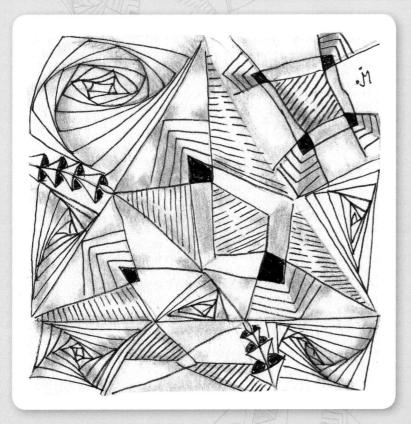

Tangles used:
Marnie, Paradox
and Puchong.

Tangles used: Chillon and Molygon with Molygon shapes filled in with Tipple, Flux-like shapes and Shattuck.

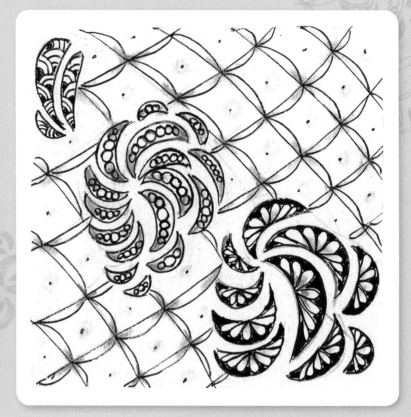

STRING 170

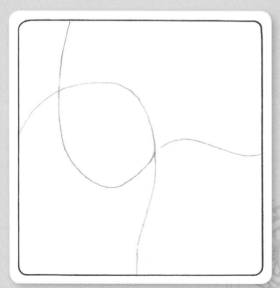

MOLYGON

A Zentangle® original

This tangle from Rick and Maria is easy enough, but it's worth exploring further as the shapes you form can be filled with other tangles.

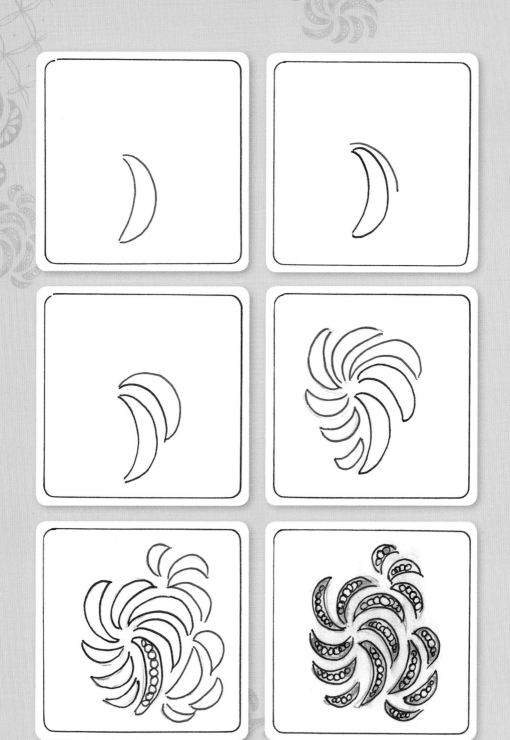

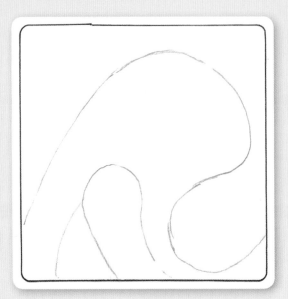

STRING 093

MOOKA – INFURLED

A Zentangle® original

This is a very popular tangle as it is very relaxing. It is best to start with the infurled variation as it is easier than the unfurled version (see p.98–9). Mooka is done with a continuous stroke.

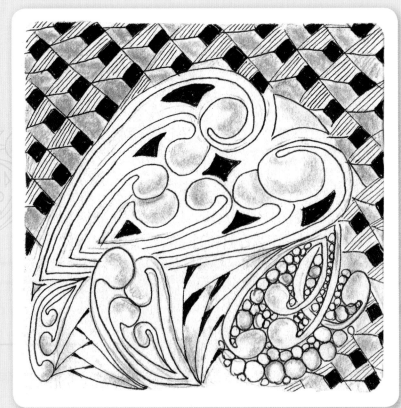

Tangles used: Betweed, Dex, Mooka and Tipple.

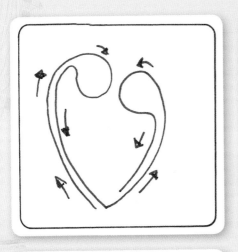

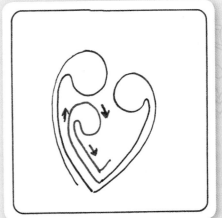

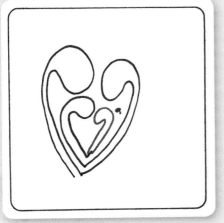

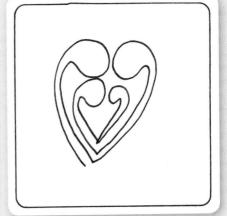

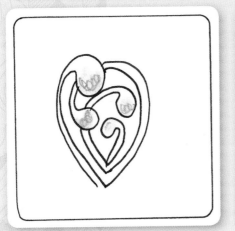

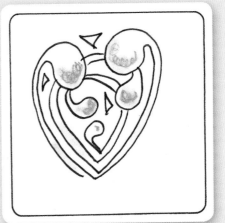

MOOKA – UNFURLED

A Zentangle® original

This version of Mooka is a little more difficult than the infurled version but it will become easier with practice. This gives quite a botanical look which becomes even more reminiscent of floral profusion as you intertwine one Mooka with another. You can vary the size of the 'pods' for different effects.

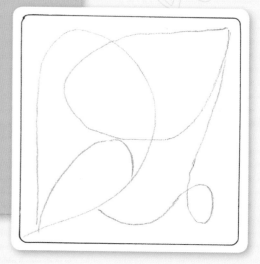

STRING 056

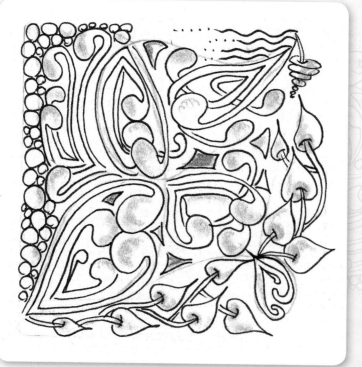

Tangles used: Mooka, Msst, Poke Leaf and Tipple.

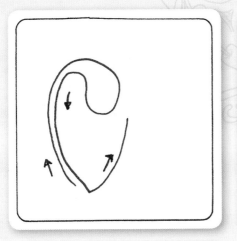

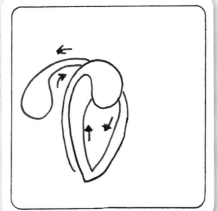

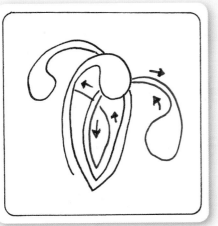

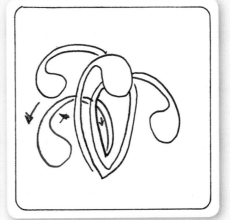

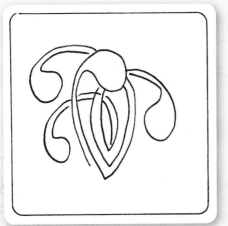

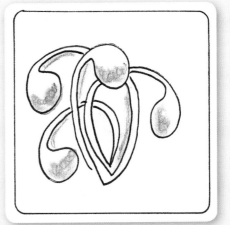

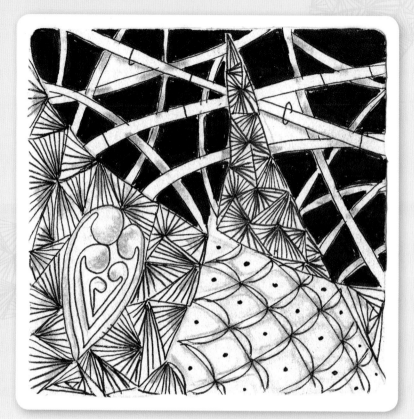

STRING 065

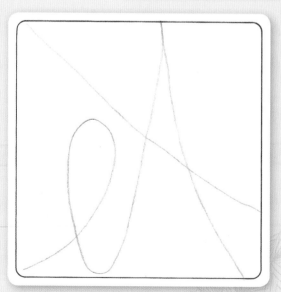

MUNCHIN

A Zentangle® original

This tangle by Molly Hollibaugh is based on a triangle formed from random dots. It is a good one with which to make an interesting background for a ZIA.

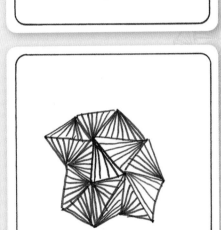

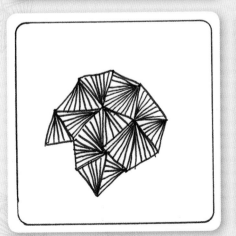

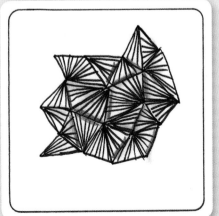

NARWAL

Samantha Taylor CZT, USA
www.facebook.com/
zentangleeccentric

This is a fun tangle and it is well
worth finding Samantha's video
on tanglepatterns.com to see
what she does with it. I have
taken a simple approach here,
but you will discover that there is
a lot to explore with this one.

STRING 146

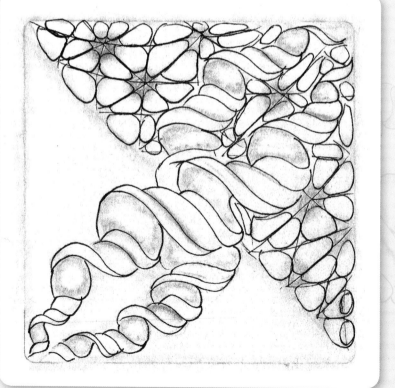

Tangles used:
Narwal and
'Nzeppel.

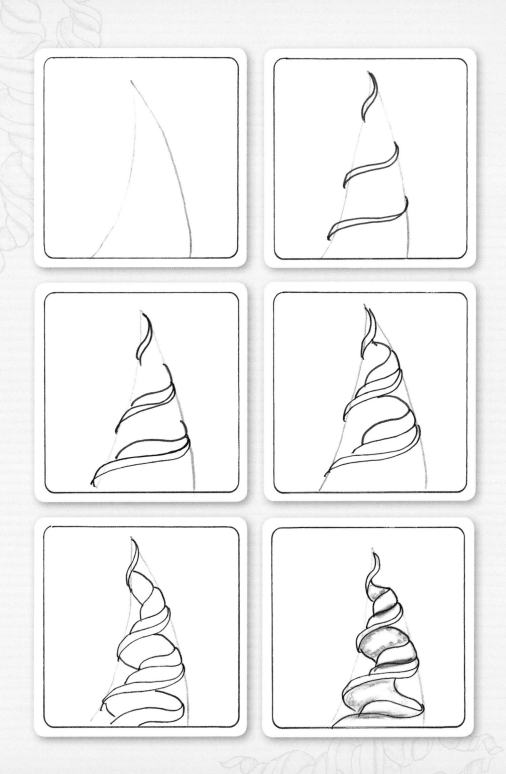

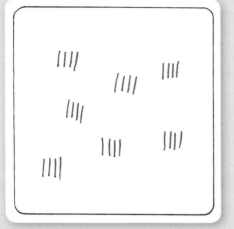

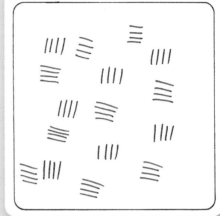

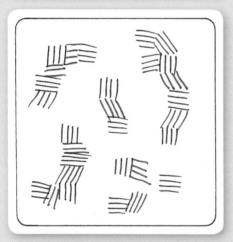

NEXTON

A Zentangle® original

A good tangle for filling in those little spaces you don't know what to do with, Nexton becomes more challenging as you join all the lines together. It gives a rather woven look when finished.

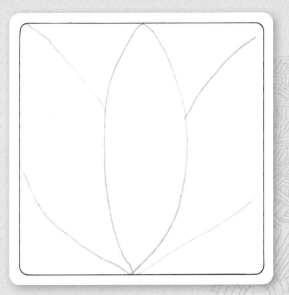

STRING 034

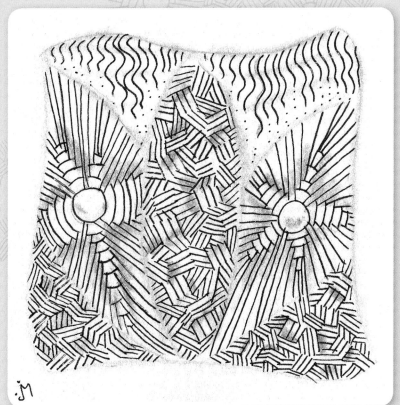

Tangles used:
Arukas, Msst
and Nexton.

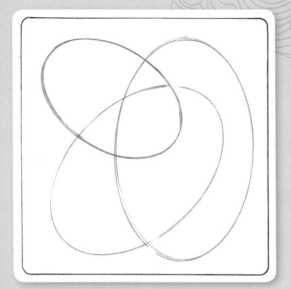

STRING 053

NIPA

A Zentangle® original

Nipa is an easy tangle with different ways of shading. Don't feel you need to fill in the whole tile with your tangles – there is nothing wrong with leaving some blank space, as I have done here.

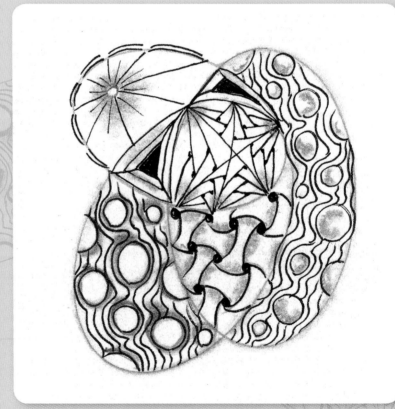

Tangles used:
Betweed,
Fassett, Huggins,
Marbaix and
Nipa.

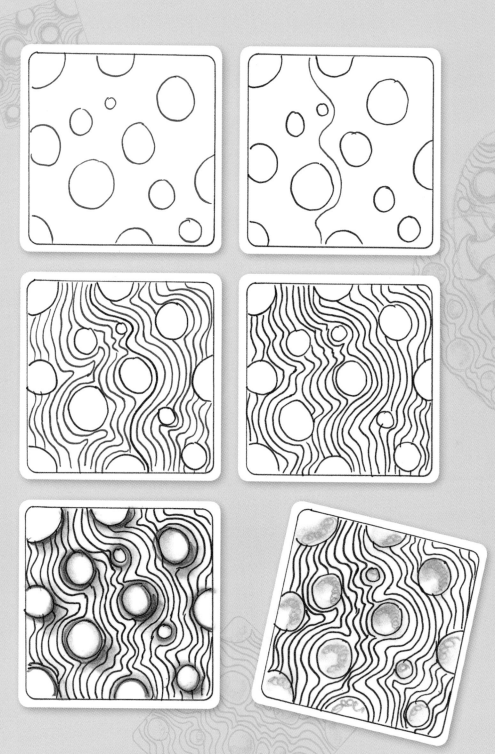

'NZEPPEL

A Zentangle® original

This is such a pretty tangle it is well worth taking your time to learn it. Once you have mastered the grid it is easy enough to draw the orbs in each space, touching the gridlines but rounding off the corners of the orbs. 'Nzeppel can be done with a random grid as well.

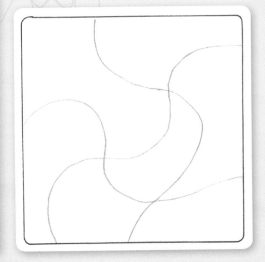

STRING 059

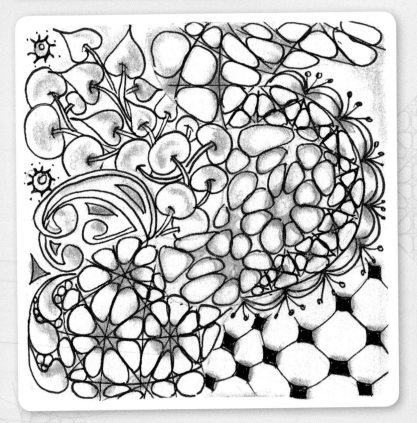

Tangles used: Florz, Mooka, 'Nzeppel, Poke Leaf, Poke Root and Puf Border.

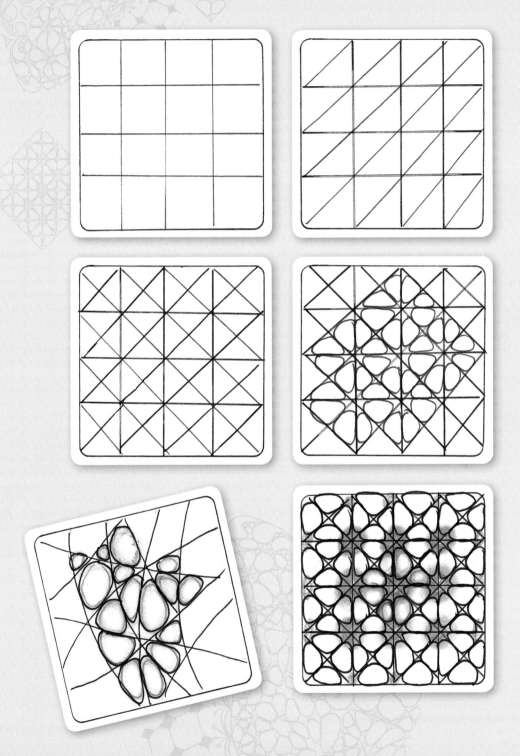

Tangles used:
Onamato and
'Nzeppel.

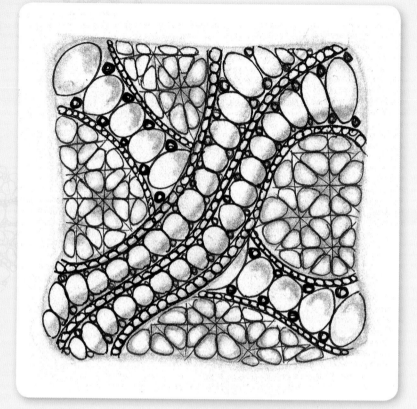

STRING 091

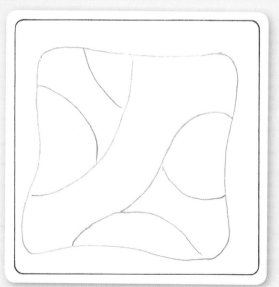

ONAMATO

A Zentangle® original

Onamato is an easy tangle
to do, but varying the size
and experimenting with
the shading will give you
apparently intricate results.

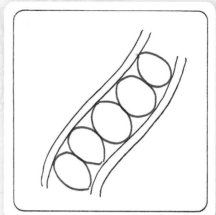

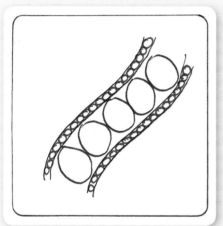

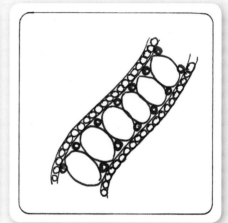

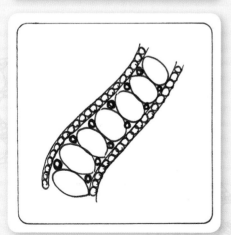

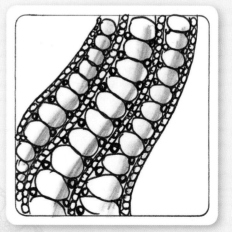

PAISLEY BOA

Amy Broady CZT, USA
tanglefish.blogspot.co.uk

There is a lot of scope for varying this tangle, for example by adding auras or filling in the shapes with other tangles such as Btl Joos. Even in the simple form I have done here it is very effective.

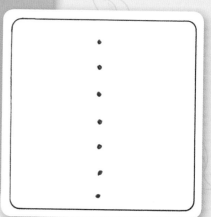

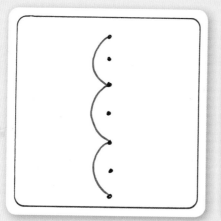

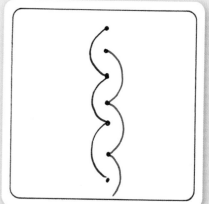

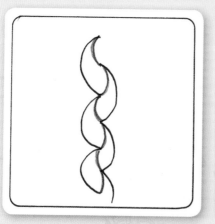

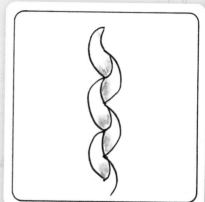

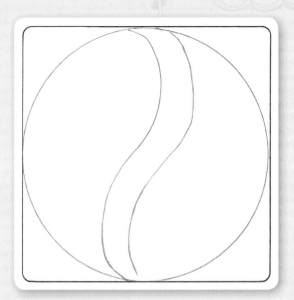

STRING 077

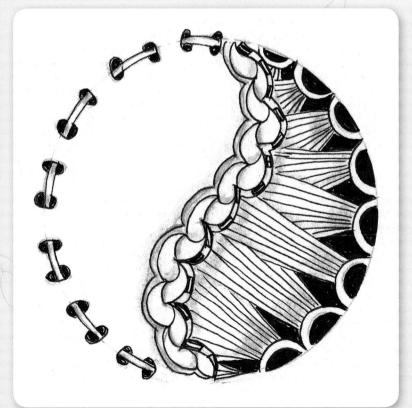

Tangles used:
Footlites, Laced
and Paisley Boa
with Btl Joos.

PAPERMINT

Sandy Hunter CZT, USA
www.tanglebucket.blogspot.com

This flower-like tangle can be done in many different sizes. A black background makes for a more dramatic look. Tipple is a good tangle for filling in around Papermint.

STRING 102

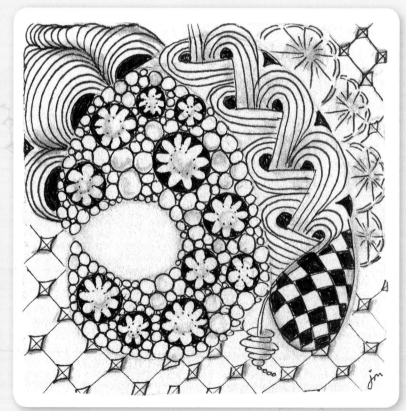

Tangles used:
Crescent Moon,
Florz, Heartrope,
Knightsbridge,
Marbaix and
Papermint.

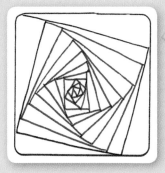

PARADOX

A Zentangle® original

This is often known as Rick's Paradox, named after its inventor. It is usually done within triangles or squares, but you could draw hexagons or other geometric shapes instead. It can also be used in a border, either by doing one Paradox clockwise and the next anti-clockwise or by drawing them all going in the same direction to form a completely different pattern. The final illustration shown here is two triangles, one going in a clockwise direction and the other anti-clockwise to form a shell-like pattern.

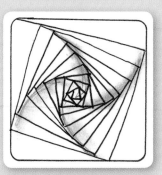

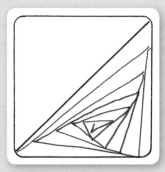

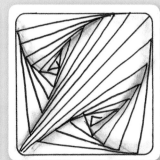

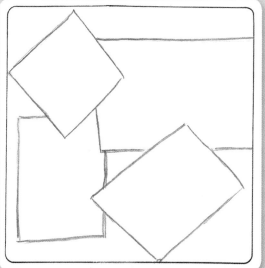

STRING 057

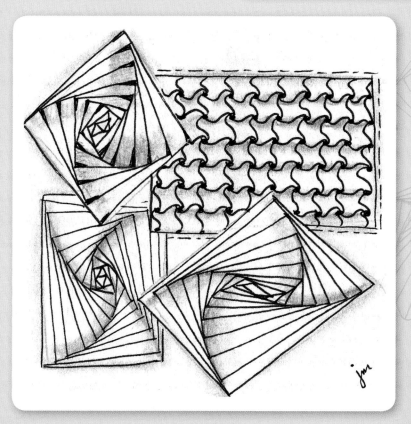

Tangles used:
Cadent and
Paradox.

POKE ROOT AND POKE LEAF

A Zentangle® original

This tangle can be done with the berry-like shapes all the same size, but varying the size of the berries gives a more interesting effect. Add shading for a more rounded look. The final illustration here is Poke Leaf, which is very similar to Poke Root but, as you might expect, more leaf-like!

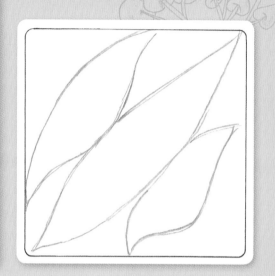

STRING 105

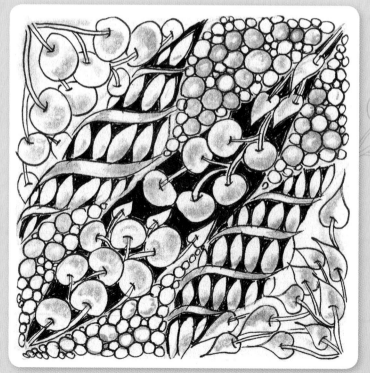

Tangles used:
Poke Leaf, Poke Root,
Purk and Tipple.

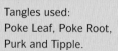

PRINTEMPS

A Zentangle® original

A spring-like shape, Printemps can be varied
by leaving a little gap as you draw the spiral,
giving it a highlight.

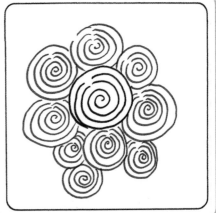

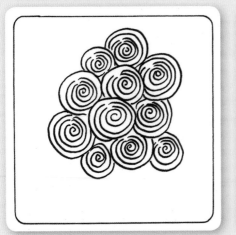

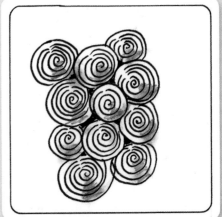

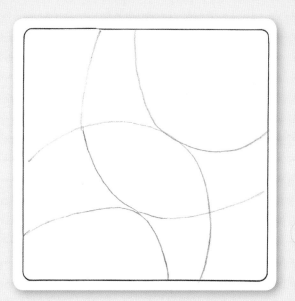

STRING 135

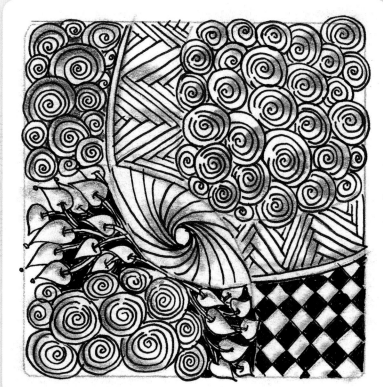

Tangles
used: Hibred,
Knightsbridge,
Poke Leaf,
Printemps and
Sparkle.

PUCHONG

Michelle Lim CZT, Malaysia

An easy tangle, Puchong can be varied a lot to give different effects. You could use it running through a ZIA or even as a border. Three variations are shown on the tile.

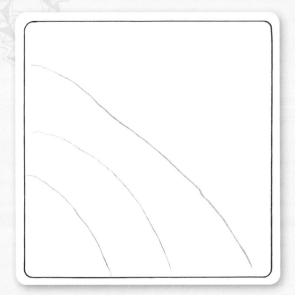

STRING 157

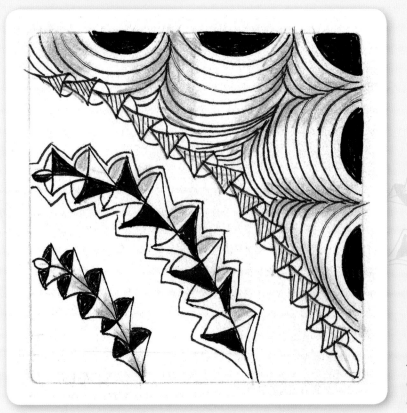

Tangles used:
Crescent Moon and Puchong.

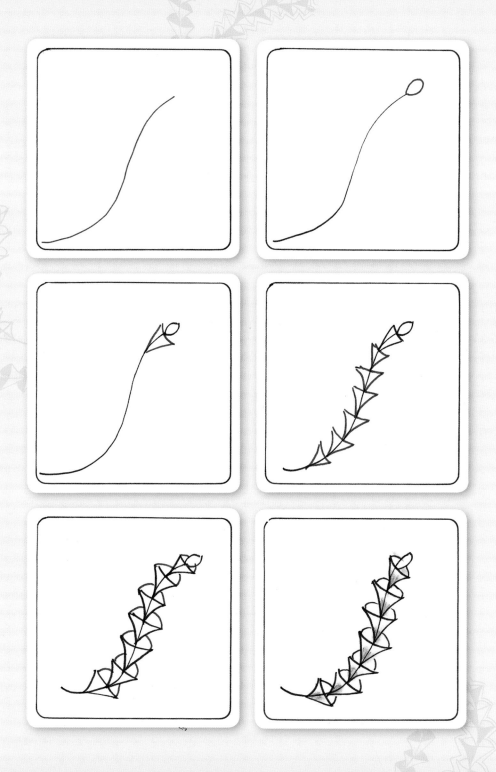

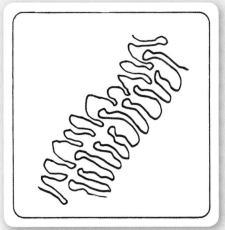

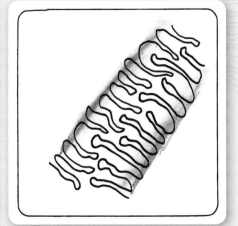

QUABOG

A Zentangle® original

A tangle that suggests foliage, Quabog can be varied by
changing whether the 'fronds' face each other as in the original
tangle or are drawn in the opposite direction, as seen in my tile.

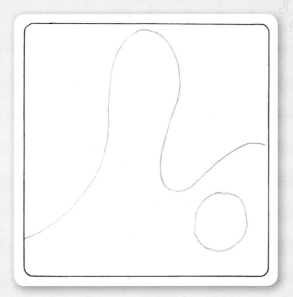

STRING 122

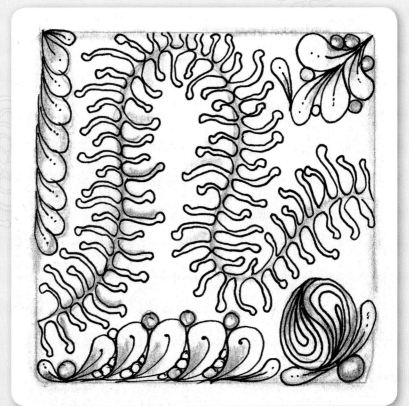

Tangles used:
Cruffle, Flux and
Quabog.

RAIN

A Zentangle® original

This can be quite a dramatic tangle that rather suggests lightning, implying that the rain is heavy! It is varied by drawing an aura around it, either on both sides or on just one. The aura is shown on the fourth step-out.

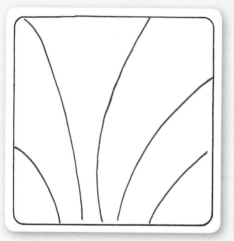 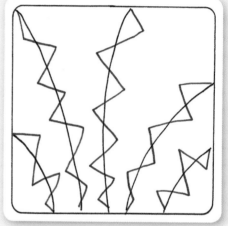

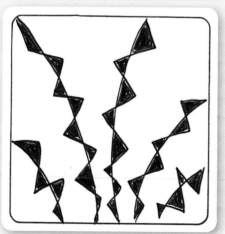 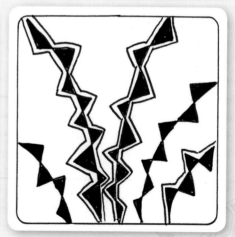

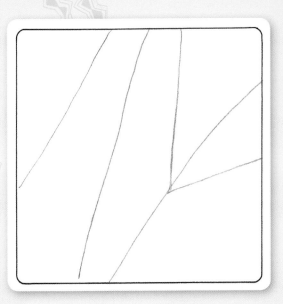

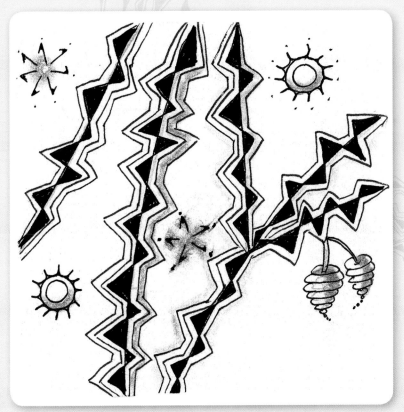

Tangles used:
Joy, Rain,
Widget and
Zinger.

RAIN

127

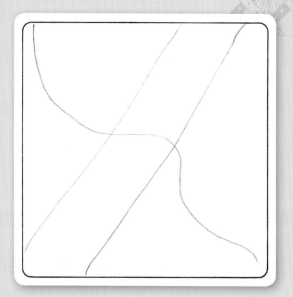

STRING 165

RIVETING

Amy Broady CZT, USA
tanglefish.blogspot.co.uk

Once you have mastered Riveting you could also try it with curved lines – just make sure that the second set of bands goes behind the first.

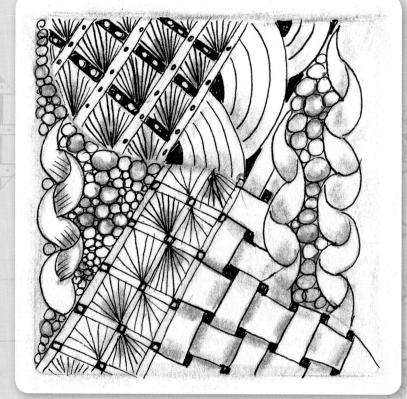

Tangles used:
Paisley Boa,
Riveting,
Shattuck, Tipple
and W2.

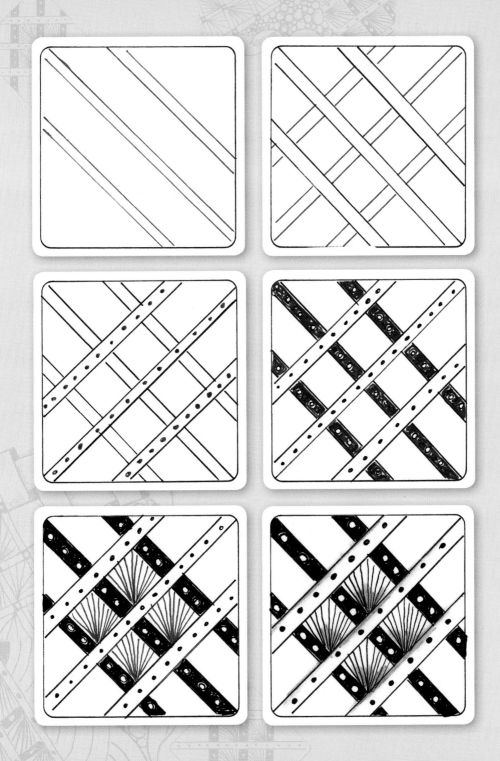

Tangles used:
Rubenesque only.

RUBENESQUE

Hannah Geddes CZT, UK
www.tangledwebcreations

Rubenesque has a mandala-like feel to it. To make it easy I used a circle as a string and started by drawing the zig-zag around the circle. I built the pattern from there. It would make a nice frame or the beginning of a mandala, from which the centre could be filled in.

STRING: Circle

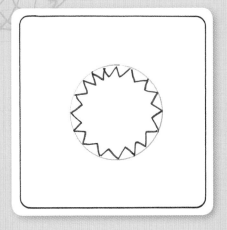

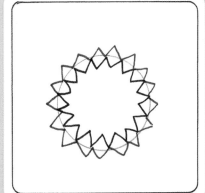

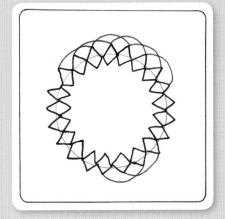

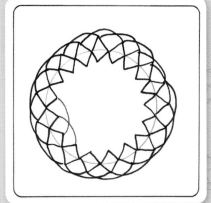

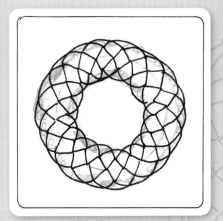

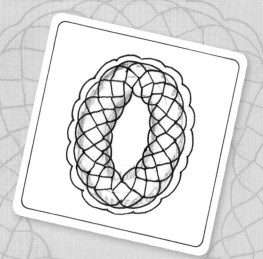

SHOWGIRL

Vicki Bassett CZT, USA

Vicki has shared several of her tangles on tanglepatterns.com and I particularly like this one for its lively feel. I have used it very simply entwined with Tipple, but the whole tile could be filled with tangles.

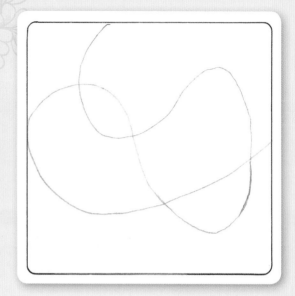

STRING 083

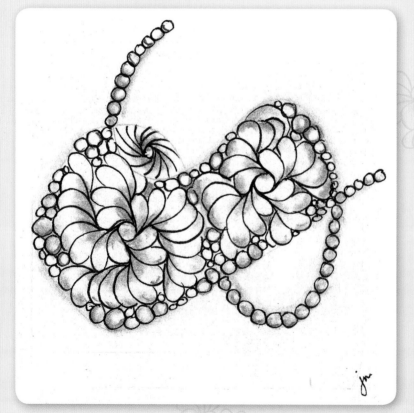

Tangles used:
Showgirl, Sparkle and Tipple.

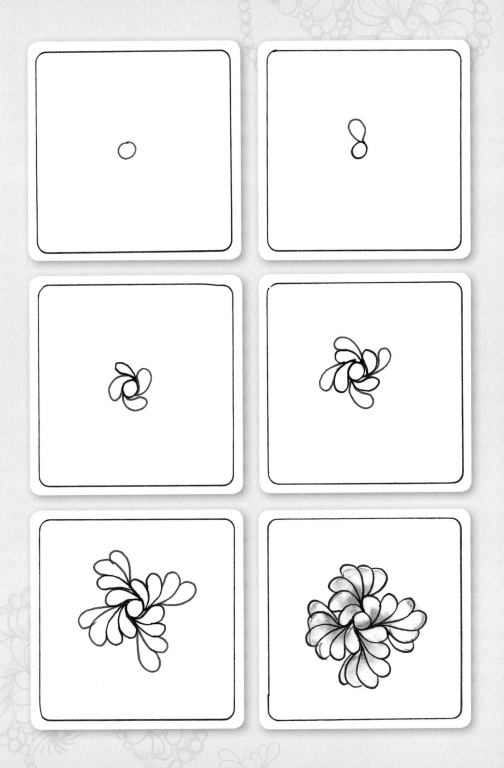

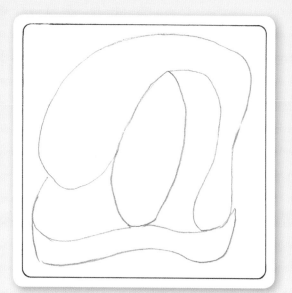

SNAIL

A Zentangle® original

This tangle is easily varied by changing the number of auras you draw around it. Using it in different sizes adds interest to an artwork.

STRING 016

Tangles used: Cruffle, Flux, Garlic Cloves and Snail.

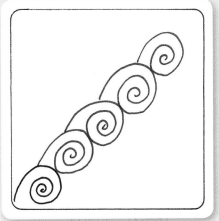
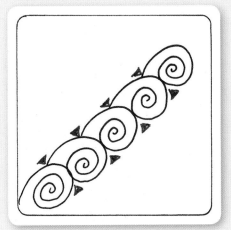
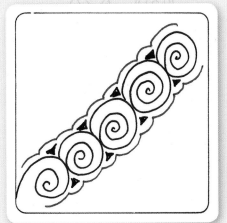
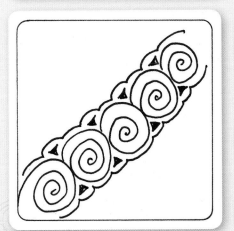
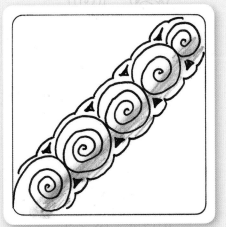

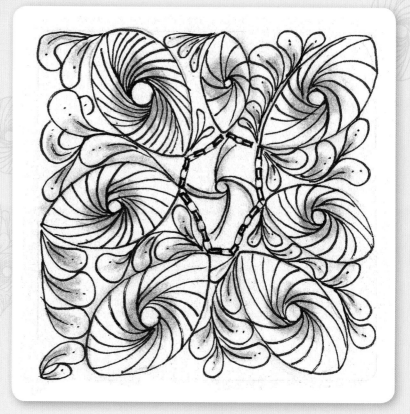

STRING 141

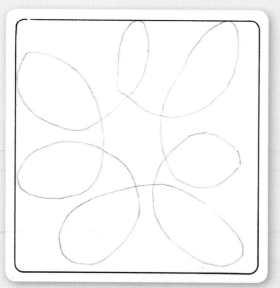

SPARKLE

Sharon Caforio CZT, USA

This was the perfect tangle
to team with string 141.
Dividing it into sections as
you draw is easier than trying
to go round in a circle.

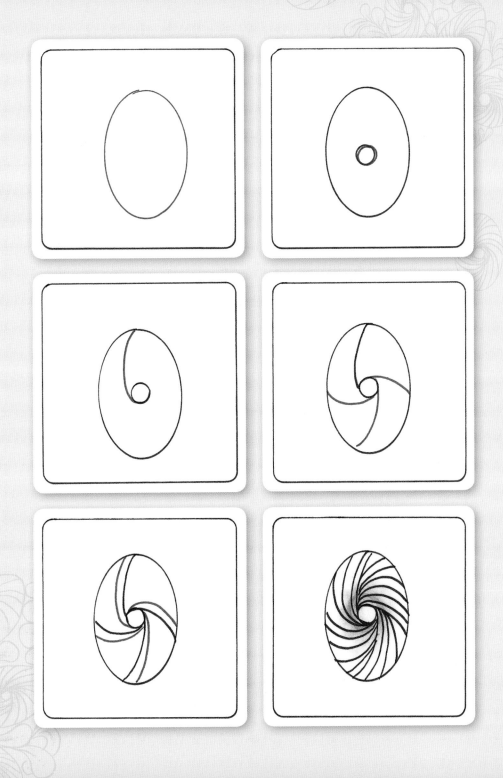

SPRIGS

Michele Beauchamp CZT,
Australia
shellybeauch.blogspot.
co.uk

This leafy pattern looks effective with small leaves but is harder to draw. Practise first with larger leaves until you can draw it fluently, then scale down for some variation.

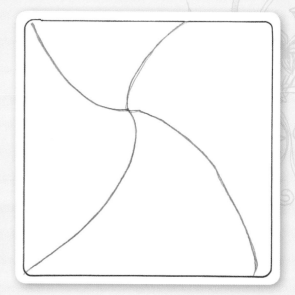

STRING 054

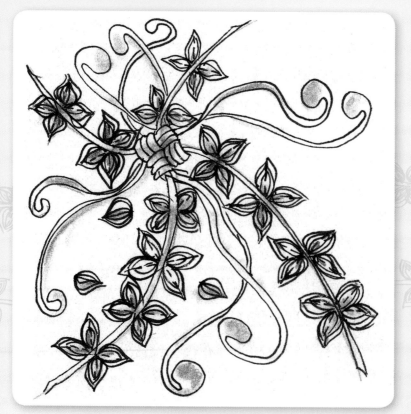

Tangles used:
Mak-rah-mee
and Sprigs.

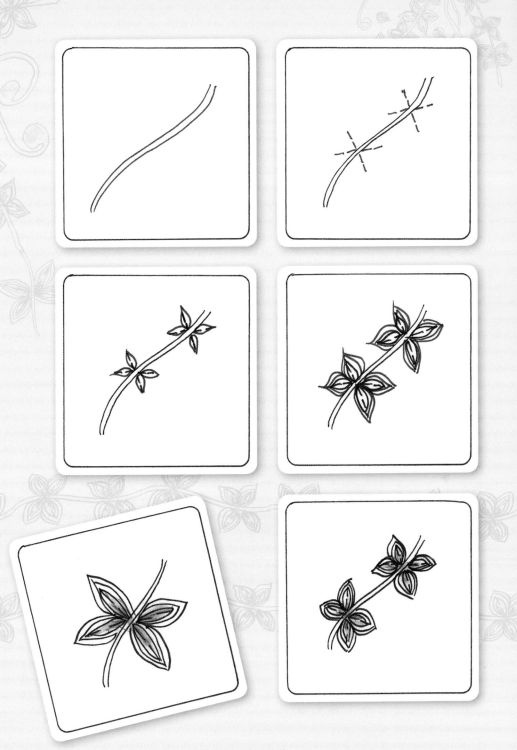

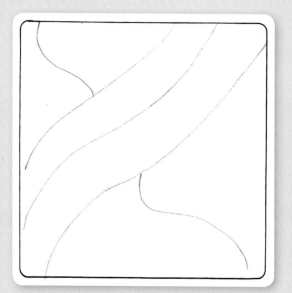

STRING 094

STRIRCLES

A Zentangle® original

There is lots of scope for varying this tangle as shown, using Crescent Moon and Tipple to change the look instead of filling in solidly with black.

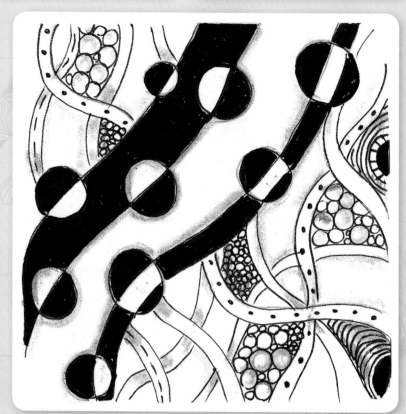

Tangles used:
Crescent Moon,
Hollibaugh,
Strircles and
Tipple.

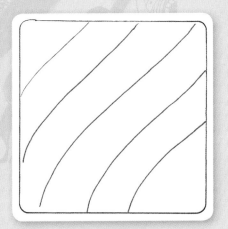

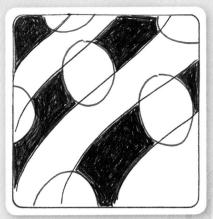

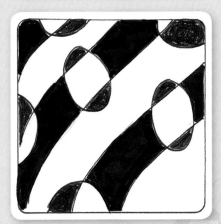

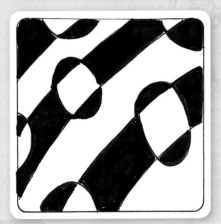

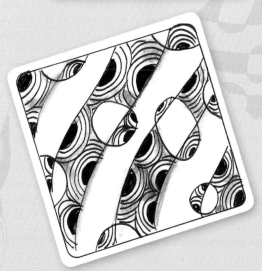

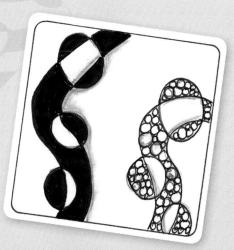

TIPPLE

A Zentangle® original

This is one of the most useful tangles to learn as it is just circles that can be used often in backgrounds or where you only have a small space to fill. Do it carefully and mindfully, taking your time to draw the circles touching each other. Make them different sizes and shade the largest.

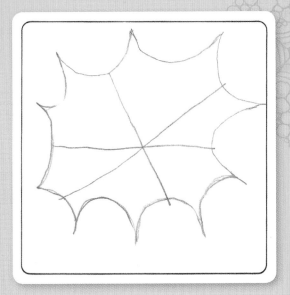

STRING 126

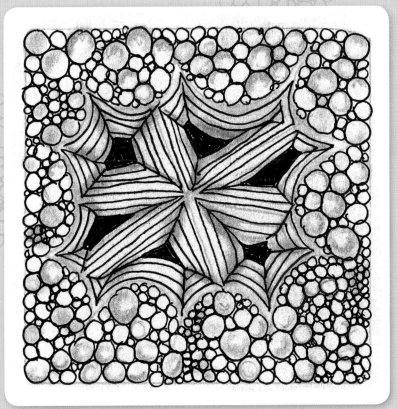

Tangles used:
Fassett and
Tipple.

TIPPLE

VEGA

A Zentangle® original

This makes a nice border and also looks good running through a ZIA in this ribbon-like string.

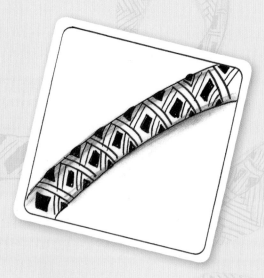

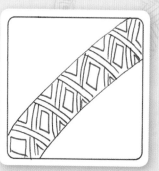

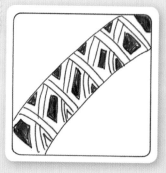

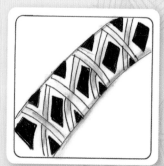

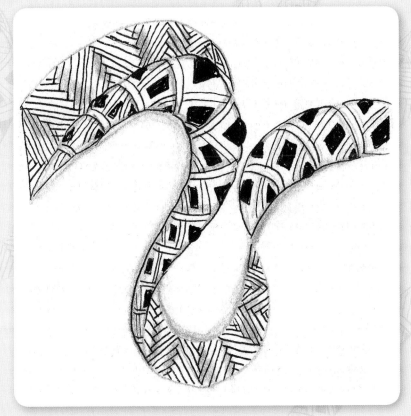

Tangles used:
Hibred and Vega.

VERDIGOGH

A Zentangle® original

You can vary this leafy pattern by increasing or decreasing the number of fronds and drawing them either square or pointed. Using a thicker pen will give a different effect. I like to combine Verdigogh with flowery tangles.

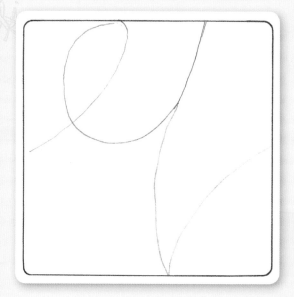

STRING 076

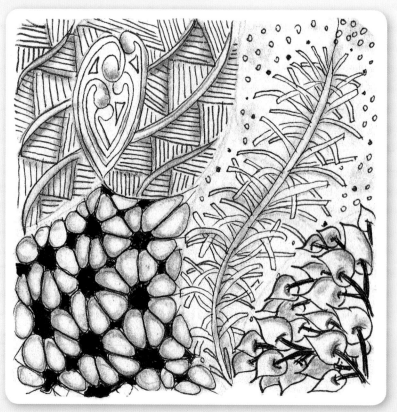

Tangles used: Mooka, 'Nzeppel, Poke Leaf, Shattuck and Verdigogh.

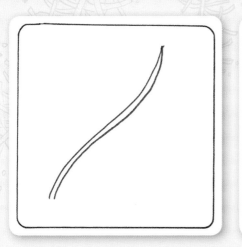

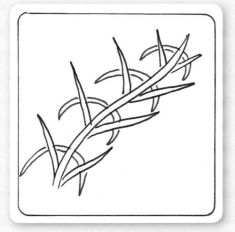

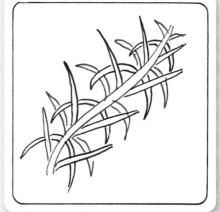

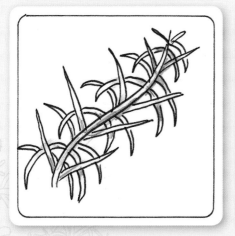

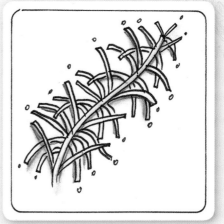

VING

Amy Broady CZT, USA
tanglefish.blogspot.co.uk

Ving is another grid-based tangle from Amy
(see also Riveting, p.128–9). You can shade
along the grid lines as well as where the
lines meet. Leaving a little gap creates a
highlight to give the impression of a sparkle.

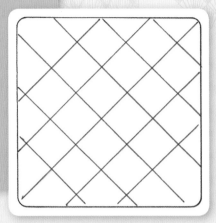

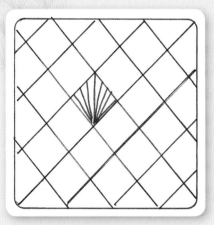

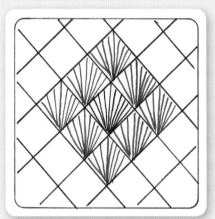

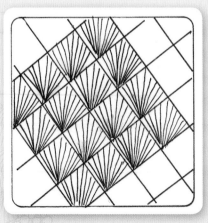

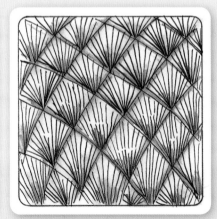

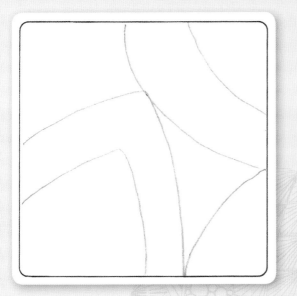

STRING 139

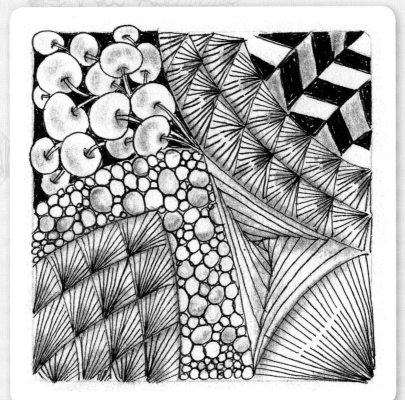

Tangles used:
Jonquil,
Paradox, Poke
Root, Tipple
and Ving.

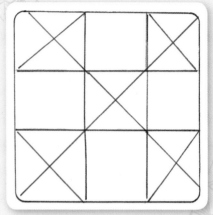

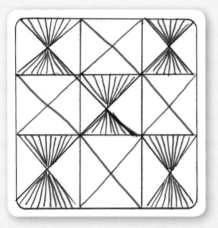

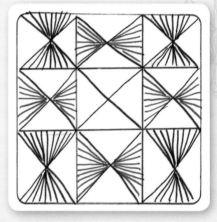

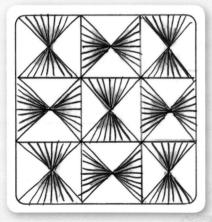

VINK

Amy Broady CZT, USA
tanglefish.blogspot.co.uk

Like Riveting and Ving, this is a grid-based pattern. Once you have drawn the spokes going vertically, rotate the paper to get some going horizontally.

STRING 027

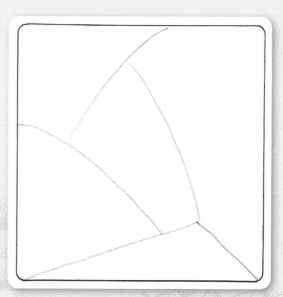

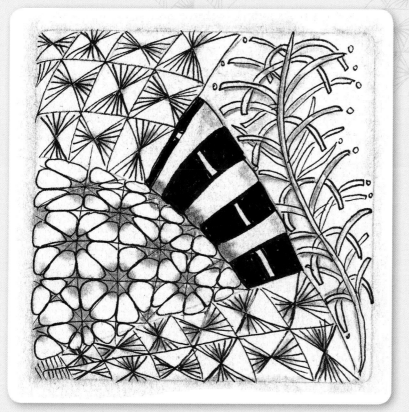

Tangles used:
Btl Joos,
'Nzeppel,
Verdigogh
and Vink.

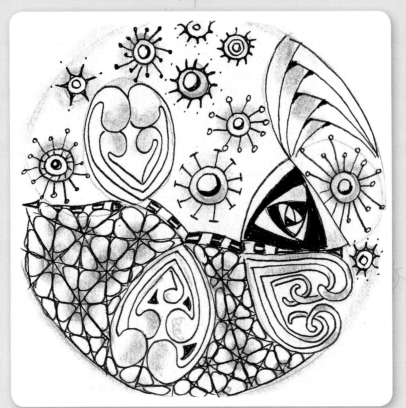

Tangles used:
Betweed, Mooka,
'Nzeppel,
Paradox and
Widget.

STRING 038

WIDGET

Kate Ahrens CZT, USA

This is a tangle that you
can add to any small
space. I think it adds a real
sparkle to any ZIA.

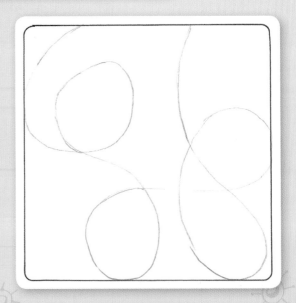

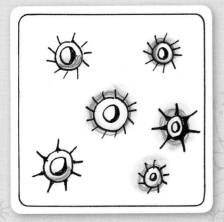

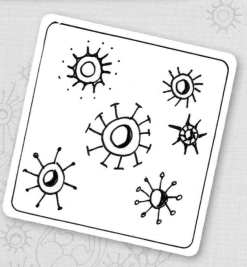

YINCUT

A Zentangle® original

Making this on a diagonal grid
gives a pleasing effect and leaving
a highlight enhances the pattern.
Shading along the grid lines as on
the fifth step-out looks good, as
does shading where the points meet
(sixth step-out). If you combine this
with curving lines you'll achieve quite
a three-dimensional effect.

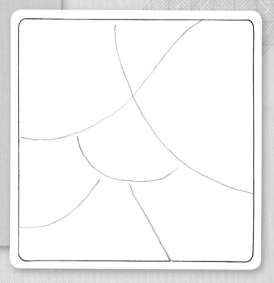

STRING 109

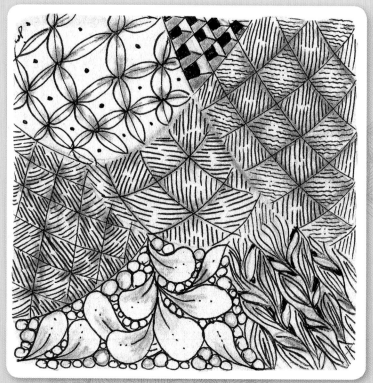

Tangles used: African
Artist, Bales, Cubine,
Flux, Tipple and
Yincut.

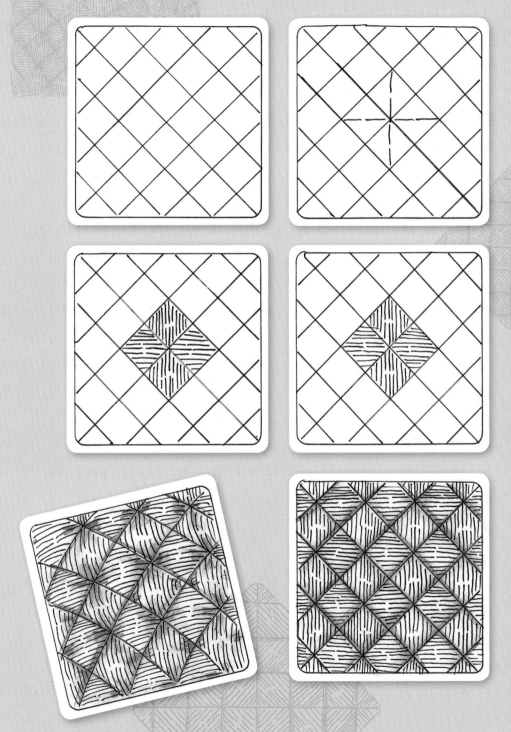

ZANDER

A Zentangle® original

Zander can be used as a border but will also work well running through your work. It looks good with the edges curved to give a pinched-in appearance. You can vary Zander by doing S-shaped bands rather than a backward C, altering the size of the band, adding shading and leaving a highlight, as in the final illustration.

STRING 070

Tangles used: Garlic Cloves, Static, Tipple and Zander.

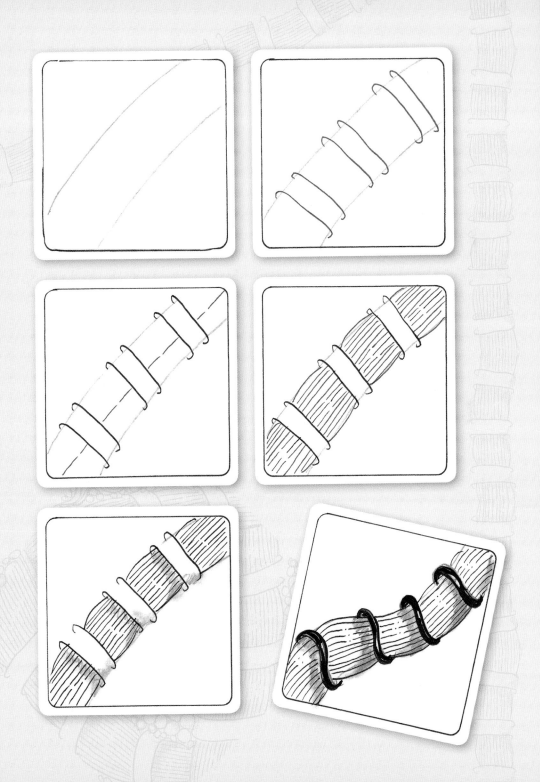

ZENITH

A Zentangle® original

This is an attractive tangle for a border or for starting off a mandala by drawing it around the edge of the circle. You will find it easier if you start with two circles for a string and then draw Zenith in between the circles to form a frame. I have done this step-out in a simple form; you will find it useful to check out the zentangle.com website to see how Rick and Maria have varied this lovely tangle.

STRING: Two circles

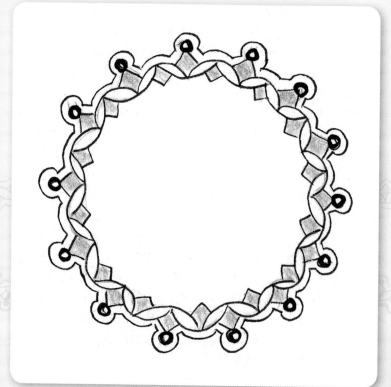

Tangles used:
Zenith only.

ZINGER *A Zentangle® original*

This is a great tangle to use as an enhancement, or add-on feature. It is easy to draw in two different ways – see the first three step-outs and then the more enclosed stroke that follows.

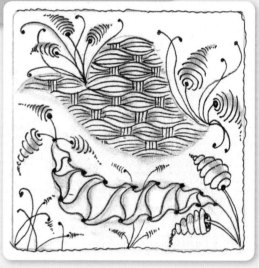

Tangles used: Bask-it, Cadent, Fescu and Zinger.

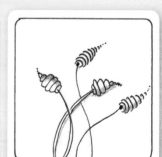